RotoVision

CAROLYN KNIGHT & JESSICA GLASER

THE GRAPHIC DESIGNER'S GUIDE TO
EFFECTIVE VISUAL
COMMUNICATION

creating hierarchies with type, image, and color

THANKS

There are many people and organizations who have helped us during the writing of this book and we would like to take this opportunity to thank them for their support, interest, and assistance. We have particularly appreciated the patience and encouragement from RotoVision, The University of Wolverhampton, our families and friends. A big thank you must also go to all the designers who have so kindly submitted work whether or not it has been included within the following pages.

A ROTOVISION BOOK

PUBLISHED AND DISTRIBUTED BY ROTOVISION SA
ROUTE SUISSE 9
CH-1295 MIES
SWITZERLAND
ROTOVISION SA
SALES & EDITORIAL OFFICE
SHERIDAN HOUSE, 112/116A WESTERN ROAD
HOVE BN3 1DD UK
TEL: +44 (0)1273 72 72 68
FAX: +44 (0)1273 72 72 69

EMAIL: SALES@ROTOVISION.COM
WEB: WWW.ROTOVISION.COM

10 9 8 7 6 5 4 3 2 1

ISBN: 2-88046-810-8

ART DIRECTOR LUKE HERRIOTT
DESIGNED BY BRIGHT PINK
PHOTOGRAPHY BY XAVIER YOUNG

REPROGRAPHICS IN SINGAPORE BY PROVISION PTE. LTD.

TEL: +65 6334 7720
FAX: +65 6334 7721

CONTENTS

INTRODUCTION

Have you ever been confronted with shelf upon shelf of soap powders and washing potions and been totally unable to find the one that you want? Every packet, bottle, bag, and box is covered with vivid, colorful graphics vying for your attention and seeking to secure your purchase. This riotous assembly of text, image, and color, with each element appearing to have equal prominence, can be too much to take in at once. When everything is presented in this way, all on one level, whether bright and loud or restrained and quiet, it is difficult to know where to look first, and the design fails to maintain your active interest and concentration.

Over time, most product categories have acquired a distinctive and somewhat synergic appearance, but the soap aisle provides an excellent display of designs that have the same visual emphasis throughout. To create efficient graphic design, individual compositions need to be more sophisticated, to break down information into accessible, appealing levels that engage the audience and ensures its attention and interest. *The Graphic Designer's Guide to Effective Visual Communication: Creating Hierarchies with Type, Image, and Color* looks at the different ways in which designers organize content to reflect varying degrees of importance and relevance, and examines how their results are achieved.

What do we mean when we talk about breaking information down into levels? We mean creating hierarchies by which certain elements are made to appear very evident and others less prominent, with some to be perceived only upon closer examination. This becomes a form of layering information, not physically overlapping elements, although this technique may be used, but a sequencing of different visual ingredients to ensure that the viewer can access each, one by one. Interestingly, it is not necessarily the most important piece of information that is presented in the most distinctive manner, but whatever is considered appropriate as an attention-grabbing device.

The concept of the designer building up layers as if forming a "graphic sandwich" can be helpful in appreciating the process of creating hierarchies. Basic, simply expressed information equates to the bread, while punchy, vital, and intriguing content represents the filling. They complement each other and work as a whole to provide variety, interest, and above all, accessibility. A sandwich of all bread or all filling is unlikely to be enjoyable or satisfying; a mix of differing characteristics will encourage the reader to relish and retain the facts presented in any design.

Creating different levels of information is of paramount importance when you want to "drip feed" the viewer easily digestible amounts. In many instances, designs for such things as Web pages, brochures, and posters are charged with communicating a great deal of information. It is not merely to provide visual interest that these hierarchies are created, but also to ensure that the audience is effectively imbibing as much as possible. Image and text are categorized according to a desired order of significance; each category is given individual visual prominence in order to direct the viewer subconsciously from one to the other. To attract attention is the first aim. The order in which levels are viewed could be considered of less significance, so long as one level is sufficiently attention-grabbing to lead the reader to more detail and, ideally, on to subsequent content. There are many and varied methods of drawing attention, from using large type, bright colors, and dramatic imagery, to highlighting more frivolous or obtuse information, or appearing distinctive or unusual. However, regardless of the designer's skilled efforts, there remains the uncontrollable aspect of the viewers' personal perceptions, experiences, and

preferences. If their favorite color is pink and they adore dogs, a pink dog, however pale or obscure, can still be the most arresting element within a design!

In some instances, levels of information are not included because their content is essential, but rather to introduce ambient subject matter in order to set the scene or create a mood. This means it is included purely to help construct viewers' dispositions, thereby making them more receptive to the real message of a piece. For example, adding a humorous element not only attracts the reader, but also puts them in a happy frame of mind, leaving them more likely to feel open to the data in the remaining composition. Taking another approach, a subtle persuasion might be included; the luxurious use of space suggests to viewers, on a subconscious level, that the content of a layout is more valuable and desirable.

The Graphic Designer's Guide to Effective Visual Communication showcases and discusses acknowledged and interesting examples of visual hierarchies produced by designers from around the world. Section One concentrates on work that is typographically driven while Section Two focuses on pieces that use imagery to control the sequencing of information. In both sections, practical exercises are included to comment on and highlight certain principles. Good design shows a balance between esthetics and function; creating successful visual hierarchies is an important element in satisfying both.

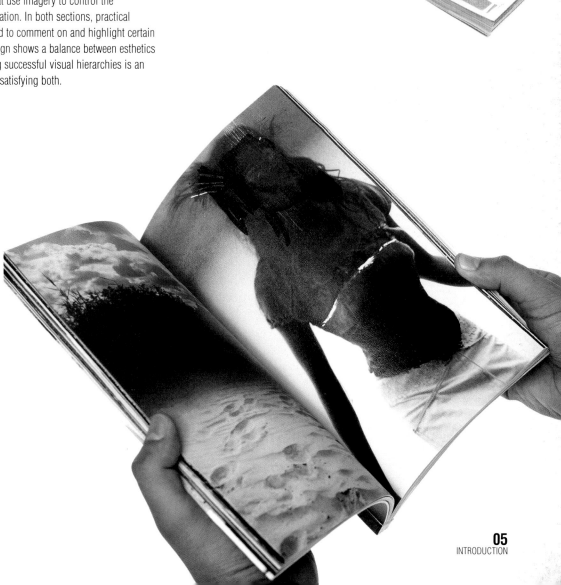

ONE

POWER

ELECTRICITY

POWER

ELECTRICITY

POWER

ELECTRICITY

TYPE DRIVEN

Section one examines the fascinating and complex realms of hierarchies that are typographically expressed. This does not mean that designs do not include imagery, or that images do not play a part in the order in which the content is perceived, simply that the most significant elements are constructed typographically.

Typographic hierarchies are predominantly governed by relationships of texture and tone. Letterforms, words, and lines of type come together to form different tonal values as well as varying characteristics of patterning; depending upon the darkness of tone generated, together with the scale and nature of texture, a viewer is attracted to a greater or lesser degree. Choices of typeface, point size, tint, weight, tracking, line spacing, and general spatial distribution affect the density of the type, and consequently, create differing degrees of light and dark. Similarly, these distinguishing characteristics impact upon the kind of pattern that is made. However, when composing differing varieties of texture and tone, designers should be prepared to make visual judgments. Logically or incrementally based changes can be a good place to start, but will not necessarily result in sufficient, meaningful change or noticeable visual difference.

Position and orientation within a layout have far less significance than density of texture and darkness of tone; key information will still be recognized as having primary importance wherever it is located, providing that it has sufficient intensity. As far as the sequencing of subsequent information is concerned, ever-decreasing tonal values will operate in tandem with Western conventions of reading from left to right and from top to bottom. Designers impose structures and style, but must always recognize the Western viewers' instinctive response to return to the left edge, and to "work their way down" a layout.

It is important to recognize that all typographic tonal and textural qualities are relative, both to each other and to the supplementary text and image on the page. Composition inevitably has a powerful influence; space around type will set it apart and give it more prominence. For example, large, bold, black, sans-serif type is not necessarily more evident or powerful than small, lightweight lettering. If the black type fills an area and bleeds off at the parameters of the page, then the reader is likely to interpret this text as image; position the smaller information in the remaining generous space and the reader's attention will almost certainly be drawn to it. Add the option of reversing type through a black box and the smaller, lighter copy takes on an even greater significance and impact. Imagery, in close association with type, can also make it possible to mute the impact of bold, large, black copy. When letterforms overlap imagery of a similar tone, or intertwine with images, they become less like parts of words, and more significant as shapes within the picture content.

THE **BIG** HOUSE IS AT THE **BOTTOM** OF THE HILL

In considering the role of type as a regulator and controller of hierarchies, it is necessary to keep in mind that letterforms make words and words have meanings. Scale, tone, and texture are always going to be relevant, but the actual words that are used also have influence. For example, highly topical subject matter, challenging language, and shocking statements are more likely to attract attention, even when represented with little dynamism. These comments apply to situations such as subheadings and main headings, but also to words and phrases that can jump into the focus of the reader from within paragraphs. Looking at the example shown, it is likely that the meanings of the highlighted words, as well as the emboldening, add to their salience.

Choices of typeface can also influence the ordering of typographic information. For example, certain families are associated with expected contexts and levels of priority. A word generated in bold, sans-serif type, all caps, may well create a strong texture and tone, but it can also have connotations of warning signs, severity, and importance, and therefore manifest more significance within a layout. Conversely, a complex or decorative typeface creating a very similar texture and tone on the page might well attract the reader initially, but because the text is difficult to read, an audience is likely to quickly move on to more accessible words. Some typefaces encompass more subjective interpretations, having personal associations or familiarity, and this too can impact upon progression, whether this be to attract or deter.

The inclusion of color in a layout brings another dimension, another modifier, to the ordering of visual data: luminosity and vibrancy are enticing; softer, paler colors appear to be knocked back; certain colors have connotations that provide meaningful relevance; small amounts of color act as highlighters. However, within the numerous roles that color

CLIENT	DESIGN	TYPOGRAPHY	ART DIRECTION
IDENTIKAL	ADAM AND NICK HAYES	ADAM AND NICK HAYES	ADAM AND NICK HAYES

can play in terms of hierarchy, one particular characteristic should not be overlooked, and that is the tonal value. Once again, it is not merely the hue that needs to be selected appropriately, but also the tone. Viewing colored typographic relationships in grayscale gives an excellent indication of prominence and priority. If color lasers function correctly when viewed in grayscale, they will certainly be equally strong in color.

As with all principles of design, those presented here serve merely as general rules and guidelines; there are no definitive dos and don'ts. The following pages in this section include examples and exercises that demonstrate some of the intricacies, fine balances, and anomalies that designers face when creating visual hierarchies.

CLIENT	DESIGN
LO RECORDINGS	KJELL EKHORN
	JON FORSS

TYPOGRAPHY	ART DIRECTION
KJELL EKHORN	KJELL EKHORN
JON FORSS	JON FORSS

NON-FORMAT
RED SNAPPER CD COVER

Non-Format's design for this CD cover uses type only, generated in a manner more usually seen on clothing labels. The reader's attention is instantly drawn to the white letterforms—delicately constructed from hundreds of strands of fine thread—which are intriguing, not only because of the bright colors in the piece, but also because of their scale, contemporary approach, and tactile character. The viewer is given a glimpse of what is conventionally recognized as the reverse of a label.

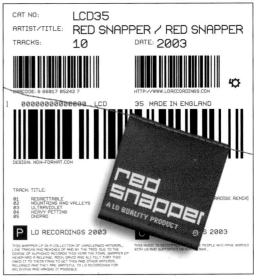

CAT NO: **LCD35**
ARTIST/TITLE: **RED SNAPPER / RED SNAPPER**
TRACKS: **10** DATE: **2003**

BARCODE: 6 66017 05242 7 HTTP://WWW.LORECORDINGS.COM

] 0000000000000 LCD 35 MADE IN ENGLAND

DESIGN: NON-FORMAT.COM

TRACK: TITLE:
01 REGRETTABLE
02 MOUNTAINS AND VALLEYS
03 ULTRAVIOLET
04 HEAVY PETTING
05 DNIPRO

P LO RECORDINGS 2003

THIS SNAPPER LP IS A COLLECTION OF UNRELEASED MATERIAL,
LIVE TRACKS AND REMIXES OF AND BY THE TRIO. DUE TO THE
DEMISE OF NUPHONIC RECORDS THIS YEAR THE FINAL SNAPPER EP
NEVER HAD A RELEASE. RICH, DAVID AND ALI FELT THAT THEY
OWED IT TO THEIR FANS TO GET THIS AND OTHER MATERIAL
RELEASED AND THEY ARE GRATEFUL TO LO RECORDINGS FOR
BELIEVING AND MAKING IT POSSIBLE

CLIENT
YEAR OF THE
ARTIST

DESIGN
DOM RABAN
PAT WALKER

ART DIRECTION
DOM RABAN

Eg.G
YEAR OF THE ARTIST BROCHURE

This spread from a brochure produced for Year of The Artist functions in an esthetic capacity, displaying allover abstract imagery in the background while the minimal text, seen first, is displayed prominently, demanding more involvement of the viewer, in order for them to understand the complex sequencing that is at its heart. And how does the sequence function? "1, 4, 12, 52, 365, 4,170, 8,760, 525,600 and 31,536,000— representing 1 year, 4 seasons, 12 months, 52 weeks, 365 days, 4,170 beverages (average number of hot drinks we each consume in a year), 8,760 hours, 525,600 minutes, and 31,536,000 seconds," explains Dom Raban, Creative Director of Eg.G.

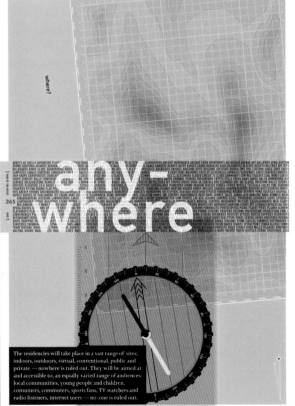

The residencies will take place in a vast range of sites; indoors, outdoors, virtual, conventional, public and private — nowhere is ruled out. They will be aimed at and accessible to, an equally varied range of audiences: local communities, young people and children, consumers, commuters, sports fans, TV watchers and radio listeners, internet users — no-one is ruled out.

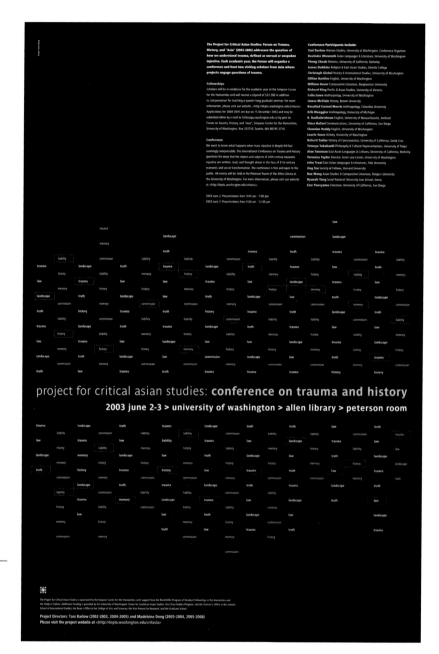

CLIENT
CRITICAL ASIAN
STUDIES,
UNIVERSITY OF
WASHINGTON

DESIGN
KAREN CHENG

TYPOGRAPHY
KAREN CHENG

CHENG DESIGN
CONFERENCE ON TRAUMA AND
HISTORY PROMOTIONAL POSTER

There are just two long lines of key information on this poster, large enough to read from a distance. There is considerable text for a poster, however, through positioning and changes of weight and color, the text sets up visual systems that lead the viewer through the composition. Although the vibrant green in the heading links with the other type, and all elements are beautifully tied into an inclusive grid, it is unlikely that much of the type will actually be read. As Cheng explains, "the overall design is intentionally abstract and severe, since high contrast and minimalism suit the seriousness of the topic, and the difficulty of emotional articulation."

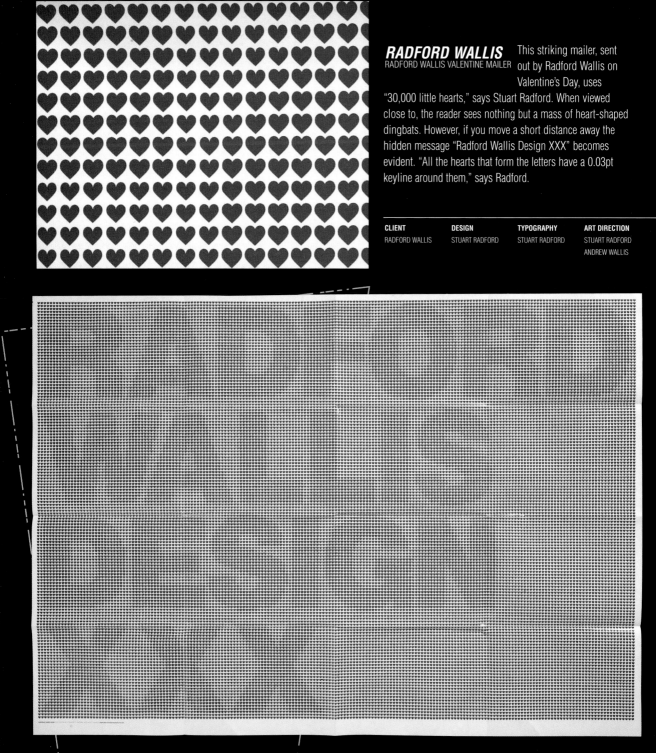

RADFORD WALLIS
RADFORD WALLIS VALENTINE MAILER

This striking mailer, sent out by Radford Wallis on Valentine's Day, uses "30,000 little hearts," says Stuart Radford. When viewed close to, the reader sees nothing but a mass of heart-shaped dingbats. However, if you move a short distance away the hidden message "Radford Wallis Design XXX" becomes evident. "All the hearts that form the letters have a 0.03pt keyline around them," says Radford.

CLIENT	DESIGN	TYPOGRAPHY	ART DIRECTION
RADFORD WALLIS	STUART RADFORD	STUART RADFORD	STUART RADFORD
			ANDREW WALLIS

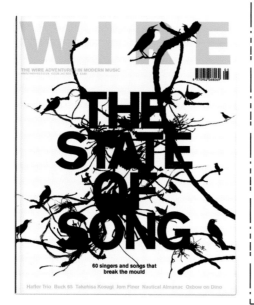

NON-FORMAT
THE STATE OF SONG
MAGAZINE SPREAD

This striking piece of all cap, sans-serif type really demands to be read first. Not only does its weight, scale, and color draw the reader in, but its central positioning, its placement on top of fine black illustration, and its white background add to the density of letterforms and prominence on the page. After taking in this title, the next level to be seen is that of the illustration, the delicate detail of which gradually appears—more and more song birds become noticeable. The smaller, lighter paragraph of text is the third and final level to be seen.

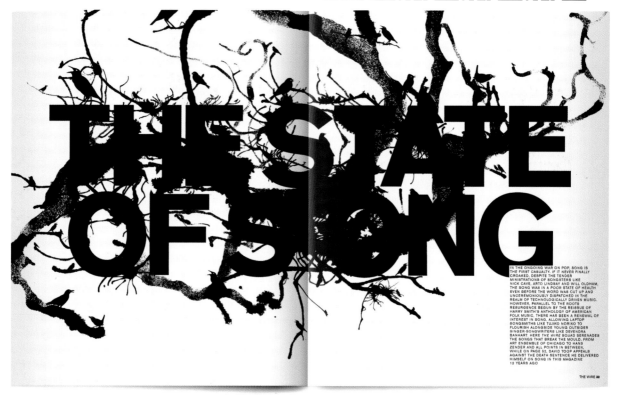

CLIENT	DESIGN	TYPOGRAPHY
THE WIRE	KJELL EKHORN	KJELL EKHORN
MAGAZINE	JON FORSS	JON FORSS

ART DIRECTION	ILLUSTRATION
KJELL EKHORN	KJELL EKHORN
JON FORSS	JON FORSS

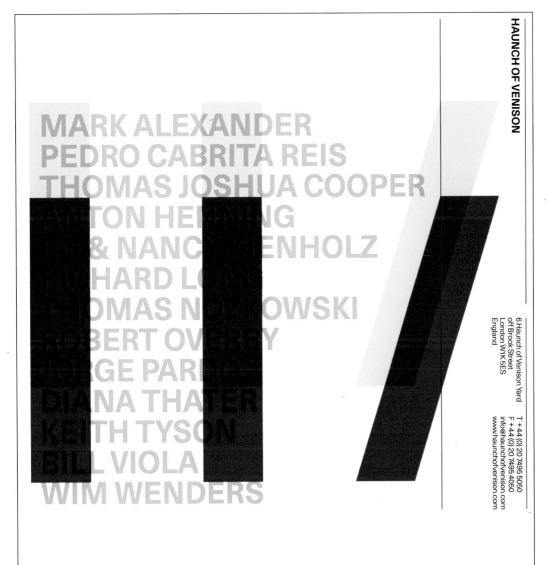

MARK ALEXANDER
PEDRO CABRITA REIS
THOMAS JOSHUA COOPER
ANTON HENNING
ED & NANCY KIENHOLZ
RICHARD LONG
THOMAS NOZKOWSKI
ROBERT OVERBY
JORGE PARDO
DIANA THATER
KEITH TYSON
BILL VIOLA
WIM WENDERS

6 Haunch of Venison Yard
off Brook Street
London W1K 5ES
England

T + 44 (0) 20 7495 5050
F + 44 (0) 20 7495 4050
info@haunchofvenison.com
www.haunchofvenison.com

SPIN
HAUNCH OF VENISON GALLERY
PUBLICITY AND IDENTITY

This purely typographic ad for the Haunch of Venison show makes interesting use of color. Text, in light cyan, overprints areas of the gallery namestyle. So what is seen first? If the reader were sitting in the optician's chair, should it not be the "black" copy on red?

CLIENT	DESIGN	TYPOGRAPHY	ART DIRECTION
HAUNCH OF VENISON GALLERY	TONY BROOK	TONY BROOK	TONY BROOK
	JOE BURRIN	JOE BURRIN	
	TOM CRABTREE	TOM CRABTREE	
	HUGH MILLER	HUGH MILLER	
	DAN POYNER	DAN POYNER	
	IAN MCFARLANE	IAN MCFARLANE	

CLIENT	DESIGN	TYPOGRAPHY
SMALL CITY	GILES WOODWARD	GILES WOODWARD
ART MUSEUMS	KELLY HARTMAN	KELLY HARTMAN
COLLECTIVE		

COPYWRITING	ART DIRECTION
DAVID GARNEAU	GILES WOODWARD
	KELLY HARTMAN

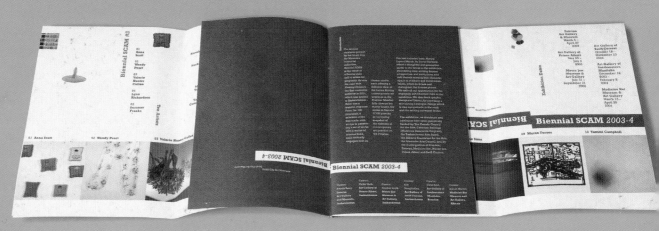

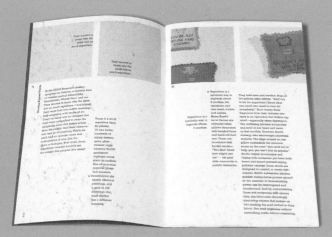

FISHTEN
BIENNIAL SCAM
(SMALL CITY ART MUSEUMS) 2003–4
EXHIBITION CATALOG

This catalog was created by Fishten to showcase the work of 10 artists. The budget was limited, but all work had to be featured in full color, extensive copy had to be accommodated, and details concerning a six-venue tour included. To overcome these challenges, Woodward and Hartman have devised a clever, full-color wraparound cover that doubles as a poster. This shows the work of all the artists, giving equal emphasis and weight to each.

The catalog itself makes dramatic and economic use of a single color. The opening spread has an impactive, solid red background that throws forward the white, slab-serif typography. Particular attention is drawn to the "Biennial Scam" heading that is positioned, on a white bar, near the bottom of the page. Contrasting with this, the next spread adopts the same unusual grid, but utilizes a white background with red text. Interestingly, although images are present within this second spread, their impact, due to halftone reproduction in single color, is very subdued.

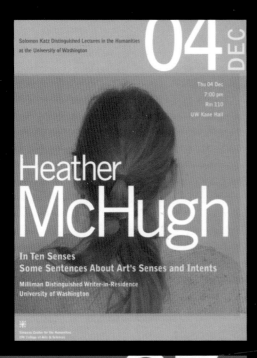

Solomon Katz Distinguished Lectures in the Humanities at the University of Washington

04 DEC

Thu 04 Dec
7:00 pm
Rm 110
UW Kane Hall

Heather McHugh

In Ten Senses
Some Sentences About Art's Senses and Intents

Milliman Distinguished Writer-in-Residence
University of Washington

Simpson Center for the Humanities
UW College of Arts & Sciences

STUDIO VERTEX
KATZ PUBLIC LECTURE SERIES 2004
POSTCARDS AND POSTERS

Studio Vertex have again produced a series of publicity cards for the Katz Lecture Series. This set of three postcards and accompanying posters make distinctive use of bright color, type as image, and muted photography. Commenting upon the hierarchical aims of his designs, Lindsay states that "in this series, the client wanted to focus foremost on the speaker, title of the lecture, and credentials, followed by date, time, place, and then the Katz and Simpson Centre sponsorship." The objectives have been clearly achieved by changing the scale and color of type, placing the speakers' names in dominant positions, and adding muted photography in a recessive background layer. Michael continues, "The addition of photography creates more visual interest and brings forward the name of the speaker."

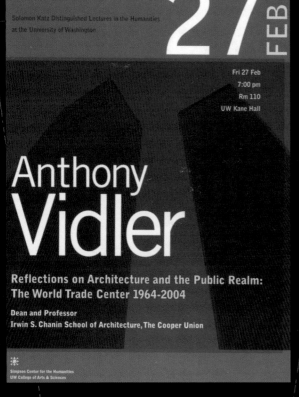

Solomon Katz Distinguished Lectures in the Humanities at the University of Washington

27 FEB

Fri 27 Feb
7:00 pm
Rm 110
UW Kane Hall

Anthony Vidler

Reflections on Architecture and the Public Realm:
The World Trade Center 1964-2004

Dean and Professor
Irwin S. Chanin School of Architecture, The Cooper Union

Simpson Center for the Humanities
UW College of Arts & Sciences

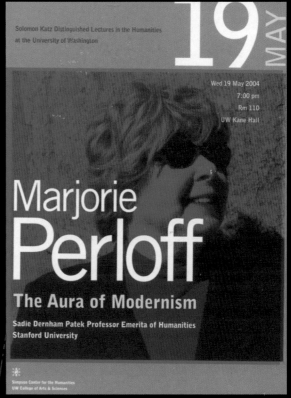

Solomon Katz Distinguished Lectures in the Humanities at the University of Washington

19 MAY

Wed 19 May 2004
7:00 pm
Rm 110
UW Kane Hall

Marjorie Perloff

The Aura of Modernism

Sadie Dernham Patek Professor Emerita of Humanities
Stanford University

Simpson Center for the Humanities
UW College of Arts & Sciences

CLIENT	DESIGN	TYPOGRAPHY	COPYWRITING	PHOTOGRAPHY
WALTER CHAPIN SIMPSON CENTRE FOR HUMANITIES	MICHAEL LINDSAY	KAREN CHENG	LESLIE JACKSON	LINDSAY, MARIANSKY, PERLOFF

EX01

CUT-AND-PASTE VISUALIZING

It can be extremely difficult to achieve sufficient variety and visual interest when creating different levels of information at the "thumbnail" stage of design. If sufficient accuracy and detail are to be captured, the mark-making process of pens and pencils is limited and very time-consuming. An interesting and unexpected alternative or addition to this initial stage involves cutting and pasting "found" samples of type and image into groupings and compositions, treating type and image in a comparatively abstract manner, and viewing the collaged elements for their qualities of texture, tone, and color rather than for making any literal sense.

In order to push the possible design options into less common and less predictable relationships, it is essential to collect a palette of samples, with a wide breadth of textures and tones, from a good selection of publications. Focus on relationships within groupings at first, and leave decisions concerning framing and ultimate scale until later. Ideally, there should be a correlation between the sampled text and image and the information that is to be included in a design; this creates realistic starting points for translating the thumbnails into the final design. It is important to appreciate that cut-and-paste samplings are likely to generate a wider selection of typefaces than will combine well in the final design. You must be prepared to rationalize; use the visualized material as an indication of whether to use a serif as opposed to a sans-serif font, and as a guide to leading, scale, color, tone, and positioning.

There is no doubt that this process of visualizing is particularly helpful in creating at least three levels of information. It will also assist you in developing variety within each level. Because of the assortment of source materials, even after rationalization, final solutions are likely to retain greater diversity and vitality.

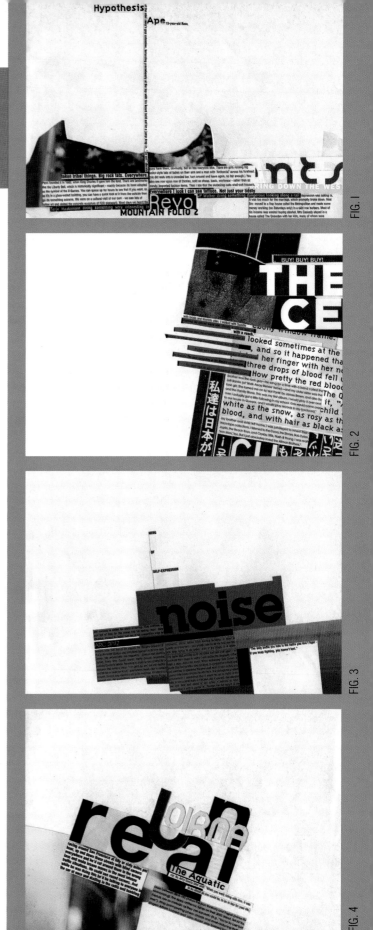

FIG. 1

FIG. 2

FIG. 3

FIG. 4

FIG. 5

FIG. 6

NEW SERIE

LA prison psychologist with ten years'

FIG. 7

This exciting selection of cut-and-paste visualizing evidences a number of design decisions that may not have been easy to make using pen or pencil alone, or, for that matter, by designing straight onto screen.

Looking at Fig. 7, combinations of cropped letterforms, lines, colored type, and image have been brought together around a striking angled axis to establish a dynamic and unusual layout. Clearly, the image and "New Serie" catch the viewer's eye first, with "LA prison psychologist …" and the three lines of red, all caps, being seen next. The viewer is then left to access the remaining information. In each level there is variety and unexpected detailing that has been enabled by this hands-on process.

GRANT MEEK
LAYOUT CONCEPTS

DESIGN	TYPOGRAPHY
GRANT MEEK	GRANT MEEK

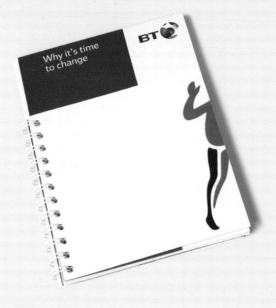

Heart

We want people to believe that BT really cares about and is committed to what it does.
This means that we need to believe in what we do, and really want to make a difference.

Brand Value

BT is passionate about communications, and works tirelessly to provide great service.

It really cares about its customers – and never lets me down.

People Value

We are determined and passionate about delivering the very best for our customers.

We come to work to make a difference.

We always give 100% of our energy.

Helpful

CAN YOU HELP ME?

SURE.
LEAVE THIS QUESTION
WITH ME AND I WILL
SORT IT OUT AND GET
BACK TO YOU.

We want people to believe that BT listens and responds. This means that we all need to pull together, and to put our customers' needs first.

Brand Value

BT sees things from my point of view, and anticipates and responds to my needs.

It takes ownership for problems, and takes responsibility for their resolution.

People Value

We pull together across BT to put the customer first.

We support each other, without waiting to be asked.

We help others succeed and celebrate their success.

SAS
BT BRAND BOOK

SAS have produced this document to explain the shift in BT's brand values. The blue section allocates a spread for each value, using large, bold type to make sure the main text is seen first, and remembered. Secondly, illustrated inserts, reminiscent of Post-it notes, are used to enforce each value. When turned over, these yellow sections allow the reader access to the text which is the third level in the hierarchy.

The final section in this design brings in real-life photography and the use of large areas of solid color. In the example shown, the reader cannot help but be drawn to the large area of bright red, and of course, the cute picture of the duck!

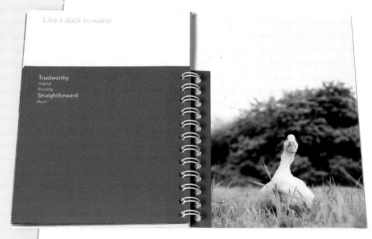

CLIENT	DESIGN	TYPOGRAPHY	COPYWRITING
BT (BRITISH TELE-COMMUNICATIONS)	GILMAR WENDT	GILMAR WENDT	PETE BROWN

ART DIRECTION	ILLUSTRATION	PHOTOGRAPHY
GILMAR WENDT	CHERRY GODDARD	LEE MAWDISLEY BT STOCK IMAGERY

CLIENT	DESIGN	TYPOGRAPHY	ART DIRECTION
JOHNSON BANKS	MICHAEL JOHNSON	MICHAEL JOHNSON	MICHAEL JOHNSON

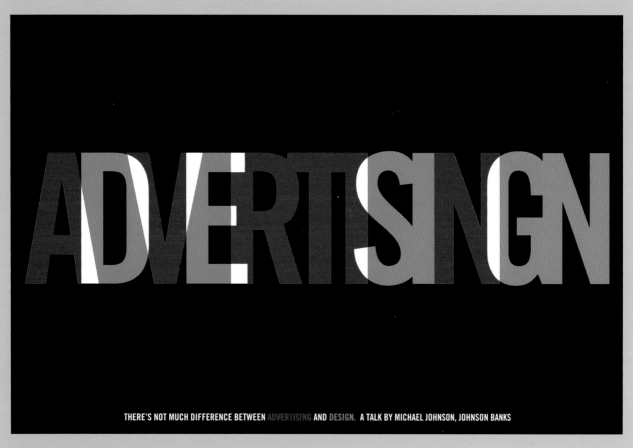

THERE'S NOT MUCH DIFFERENCE BETWEEN ADVERTISING AND DESIGN. A TALK BY MICHAEL JOHNSON, JOHNSON BANKS

JOHNSON BANKS
ADVERTISING DESIGN POSTER

This poster, designed by Michael Johnson of johnson banks to promote his talk There's Not Much Difference Between Advertising and Design, makes use of bright, contrasting colors, and bold, closely spaced, condensed type. The overlapping areas of the cyan and magenta letters are white, and stand out prominently from the black background. Using the principle of similarity, the reader is able to place all cyan letters together, creating and reading the word "Design." Following a similar method, they can then make out the word "Advertising" from the mix of magenta and cyan letters. Smaller, all cap letterforms are seen next, centered at the bottom of the poster, and these explain the theme of the talk.

BLUE RIVER
DESIGN LTD
WALL ARTISTS CATALOG

Displaying the works of a number of artists, *Wall* uses a mix of imagery and type to capture the substance of each individual's work. In each sampled spread, Lisa Thundercliffe has carefully crafted supporting text in a manner that is appropriate to the artist's work and interests. For example, on Nina Byrne's spread, type is mirrored, emulating this same feature within her shot of red roses in a white room. On Alan McGinn's page, Thundercliffe has selected a textured background and typewriter-style text to echo his fascination with mass-produced objects.

CLIENT	DESIGN	TYPOGRAPHY	COPYWRITING
WAYGOOD GALLERY STUDIOS	LISA THUNDERCLIFFE	LISA THUNDERCLIFFE	LISA THUNDERCLIFFE

ART DIRECTION	ILLUSTRATION	PHOTOGRAPHY
LISA THUNDERCLIFFE	LISA THUNDERCLIFFE	VARIOUS

CLIENT	DESIGN	TYPOGRAPHY
UNIVERSITY OF	PHILIP FASS	PHILIP FASS
NORTHERN IOWA		
GALLERY OF ART		

PHILIP FASS
2002 FACULTY EXHIBITION POSTER

In this exhibition poster, Philip Fass has selected the numerals in "2002" as a vehicle to draw in the viewer. Although they do not present the most important information, their bold, large, pink type bleeds off at both edges of the layout to create an eye-catching, attention-grabbing centerpiece. Contrasting background imagery is grayscale and divided into three sections of varying scale; much smaller black-and-white type sits within horizontal and vertical bands. "The structure is a vertical triptych," says Fass, "and the rest of the typography forms a cruciform roughly in the middle of the composition. The design is meant to stop an individual drawn in by its boldness." Initially there appear to be only two distinct levels, but the viewer moves from pink type to the black and white level—horizontal text is read first, then vertical text —and finally to the third level, the fairly abstract imagery that fills the remainder of the space.

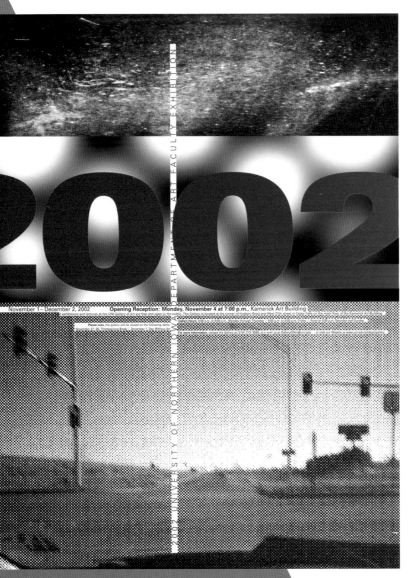

IE DESIGN + COMMUNICATIONS
IE DESIGN + COMMUNICATIONS
NEWSLETTER

This holiday newsletter and calendar from the IE Design team is packed with many diverse articles and thought-provoking facts. Images are present very much to support copy and not to dominate, although it could be debated that the shot of the Chihuahua in the floral hat grabs the reader's attention because it is so unusual and unexpected. Articles make use of colored type, and changes of typeface, scale, and orientation to create fascinating variations of texture and tone as well as emphasis. Colored backgrounds in shades of blue and green help to divide topics and add more interest.

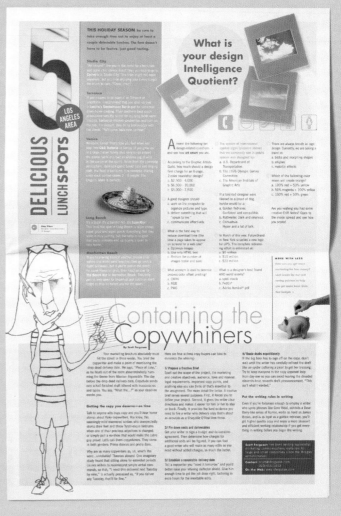

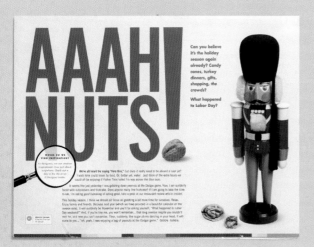

CLIENT	DESIGN
IE DESIGN + COMMUNICATIONS	MARCIE CARSON

COPYWRITING	ART DIRECTION
SCOTT FERGUSON	MARCIE CARSON
IE DESIGN TEAM	

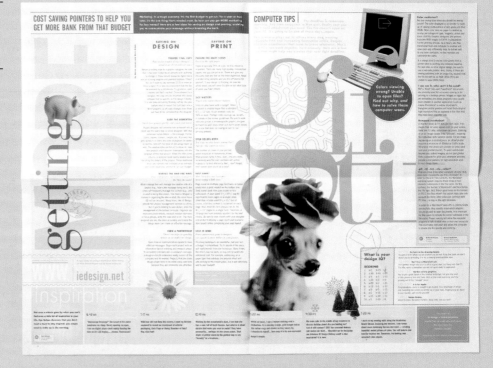

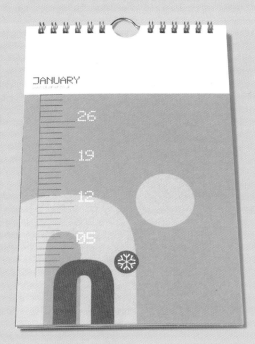

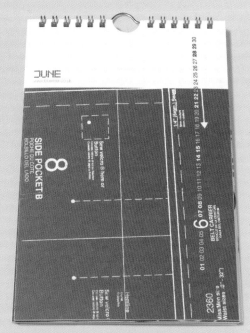

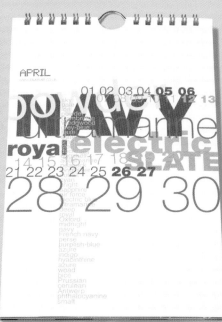

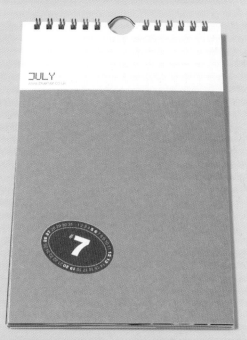

BLUE RIVER DESIGN LTD.
BLUE RIVER CALENDAR 2003

Exciting configurations of type command attention in the 2003 calendar by Blue River Design. Each page has a connection with the color blue, ranging through January's icy cool blues, April's numerous and diverse shades, June's denim theme, and July's blue, which is complementary to its orange background. In every instance the blue provides a cohesion that draws the viewer through the pages, with individual compositions and treatments configuring dynamic relationships that hold interest along the way.

CLIENT	DESIGN	TYPOGRAPHY
BLUE RIVER	LISA	LISA
DESIGN LTD.	THUNDERCLIFFE	THUNDERCLIFFE

ART DIRECTION	ILLUSTRATION	PHOTOGRAPHY
SIMON DOUGLAS	LISA	LISA
	THUNDERCLIFFE	THUNDERCLIFFE

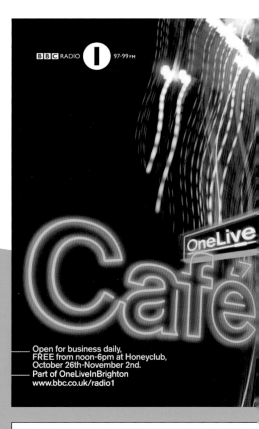

Pete Tong, Basement Jaxx,
Norman Cook, Fergie, Judge Jules,
Seb Fontaine, Dave Pearce, Lottie,
Annie Nightingale, Rob Da Bank,
Chris Coco, Tim Westwood,
Fabio & Grooverider, Gilles Peterson
Trevor Nelson, Har Mar Superstar,
Dub Pistols, Dave Clarke Live,
Adam F and special guests,
Tula, Chungking & Freeland.
For tickets & info:
www.bbc.co.uk/radio1

BBC RADIO 1

OneLive In Brighton

AllWeekAllLiveAllOnRadio1
October27th-November2nd

Brighton & Hove

BBC RADIO 1 97-99 FM

OneLive

Café

Open for business daily,
FREE from noon-6pm at Honeyclub,
October 26th-November 2nd.
Part of OneLiveInBrighton
www.bbc.co.uk/radio1

CLIENT	DESIGN
BBC RADIO 1	ROB COKE
	DAN MOORE

TYPOGRAPHY	ART DIRECTION
DAN MOORE	DAN MOORE

ILLUSTRATION	PHOTOGRAPHY
DAN MOORE	SHILA SULTANA

STUDIO OUTPUT LTD. Studio Output have used
ONELIVE IN BRIGHTON the unique outline style of
neon lettering in their
identity for OneLive in Brighton as its connotations of lively
nightclubs and current music not only create an appropriate
character, but also attract attention. Dark backgrounds,
emulating a night sky, throw out the text, which is broken
down into a particularly eye-catching yellow, together with
white, green, and blue. The outline lettering enables images
of Brighton to be layered behind the words, and adds an
element of intrigue to the designs as different elements come
to the viewer's notice. The limited color palette then provides
excellent coding for the large amount of information that has
to be communicated in some pieces.

**Consistent use of black plus blue or green type, along
with white type reversed through blue or green bars,
forms a strong hierarchy, as well as a simple system
that categorizes information. Readers quickly learn to
move from bar to bar to access the date headings, and
only move onto the details below if they are required.**

SundayOctober26th
— 2-4pm: The Car Boot Sale
Bring your beats & words and take part in the mash-up! (Sorry no drum kits but backline & decks
will be supplied). We'll also have one-to-one advice on press & promotion, home recording,
distribution, royalties and free access to music lawyers.

WednesdayOctober29th: TheDanceDay
— 1pm: One Lunch In Brighton
Two local dance acts selected in association with Brighton Underground.
— 2pm: Getting Down To Business
Seamus Haji hosts a discussion about how artists and DJs can kick off their careers.
— 3-5pm: The Dance Factory
One-to-one demo & mix listening (all material on CD please) plus advice from Seb Fontaine,
Anne Savage & Skint Records.
— 3-5pm: Stick It On
Your 15 minutes of fame beckons - come down and play us a short DJ set and win prizes
including Har Mar Superstar tickets.

ThursdayOctober30th
— 4-5pm: VJing
Find out about the art of 'club visuals' - and have a go at creating your own.

FridayOctober31st
— 2-5pm: Networking Masterclasses (one an hour)
It's not what you know; it's who you know. Making contacts is easier than you think!
Find out how you can use what you have - to get what you want.

SaturdayNovember1st
— 2-3pm: DJ Q&A
Put your questions to Judge Jules and others.
— 3-4pm: Last Chance Demo Listening
Our last one-to-one demo & mix listening session of the week (all material on CD please).

SundayNovember2nd
— 2-4pm: The Fry Up
A second helping of the best of the week's local acts from the Café.

Dance Producers & DJs

Some sessions may require booking on the day.
Please arrive early to avoid disappointment.

DOYLE PARTNERS
THE NEW YORK TIMES OP-ED
"DISEASES"

This totally typographic piece illustrates the shocking statistics relating to epidemics worldwide, and is designed to help put the SARS outbreaks of recent years into perspective. Disturbingly, the reader's attention is drawn first to the giant "Tuberculosis," with "Malaria" coming a close second; combine these with all the other dangers listed, and SARS is very clearly pushed to the bottom of the chart.

CLIENT	DESIGN	TYPOGRAPHY	ART DIRECTION
THE NEW YORK TIMES	STEPHEN DOYLE	STEPHEN DOYLE	STEPHEN DOYLE

THE EPIDEMIC SCORECARD

By Howard Markel and Stephen Doyle

Estimates of disease incidence and mortality are from the World Health Organization

The sudden appearance of an epidemic typically inspires rapt attention, panic and action. Once the crisis subsides, public attention wanes although the threat of contagion continues, especially among the world's poor.

Compare our response to severe acute respiratory syndrome, or SARS, with the more familiar germs that plague us daily. Compare it to the dangers of bad diet or getting in a car and heading out on the road. Every life is precious, but when you look at the numbers, SARS just isn't as formidable a threat as we've made it out to be. Its death rate is far lower than that for AIDS and malaria; coronaviruses, like the one believed to cause SARS, tend to be most active in the winter and early spring.

In addition to taking the steps necessary to keep SARS at bay—watching out for new cases and isolating people who are contagious to others—we would do well to channel our energies into something more lasting: a permanent, integrated and accountable global public health system for the surveillance and prevention of the microbes that are certain to emerge in the future. Right now, worldwide accounting of disease is incomplete at best, hampered in large measure by sketchy reporting from developing countries. These gaps slowed our containment of SARS and allowed rumor to spread more rapidly than reliable information. When the facts are few, it's easy for fear to fill the vacuum.

Howard Markel, professor of pediatrics and communicable diseases at the University of Michigan, is author of the forthcoming "When Germs Travel."

Tuberculosis

2 MILLION DEATHS A YEAR
8 MILLION NEW CASES A YEAR, AND CLIMBING

In the last hour, more than 200 people have died of tuberculosis

EACH YEAR 1 PERCENT of the WORLD BECOMES INFECTED with the TB GERM

ONE THIRD OF THE WORLD'S POPULATION IS INFECTED WITH

INFECTIOUS DROPLETS TRANSMITTED BY: ❋ BREATHING ❋ COUGHING ❋ SNEEZING ❋ EVEN SPEAKING ❋

TO BE EFFECTIVE, TB DRUGS MUST BE TAKEN FOR SIX TO EIGHT MONTHS

DRUG-RESISTANT STRAINS ARE INCURABLE (AND MULTIPLYING)

MALARIA

MORE THAN 100 DEATHS AN HOUR

BORNE BY MOSQUITOES

Medicines exist to fight the many strains of the malaria parasite, but public health workers are concerned about drug-resistant forms of the disease. Prevention (mosquito control) is the most effective.

1 MILLION DEATHS A YEAR
300-500 MILLION NEW CASES A YEAR

HEPATITIS B VIRUS

1 MILLION DEATHS A YEAR / 10-30 MILLION NEW CASES A YEAR

puts you at high risk for cirrhosis, liver cancer, liver failure and death.

TRANSMITTED VIA
• Mother to child at birth
• Unsafe injections or transfusions
• Sexual contact

No effective treatment. Vaccine can block chronic infection, but its high cost prevents its widespread distribution in poor nations.

DIARRHEAL DISEASES

(cholera, shigella, dysentery, typhoid, E. coli and others)

1.9 MILLION DEATHS A YEAR
mostly infants and young children

2.7 BILLION NEW CASES A YEAR

Within the last hour, 200 people have died of these diseases

Transmitted by contaminated food or water

1.5 billion people do not have ready access to clean water

AIDS

3.1 MILLION DEATHS A YEAR
5.5 MILLION NEW CASES A YEAR
42 MILLION PEOPLE ARE H.I.V.-POSITIVE

IN THE LAST HOUR, MORE THAN 300 PEOPLE HAVE DIED FROM AIDS

And...
Cardiovascular disease (heart attack and stroke) deaths: 17 million
Tobacco-related deaths: 3.5 million
Motor vehicle fatalities: 1.26 million

Measles

NEARLY 900,000 DEATHS A YEAR
30 MILLION NEW CASES A YEAR

ENTIRELY PREVENTABLE WITH A VACCINE THAT COSTS 26 CENTS AND HAS BEEN AVAILABLE SINCE 1963

24,000 DEATHS A YEAR
20 MILLION NEW CASES A YEAR

mosquito-borne Dengue Fever

INFLUENZA

250,000 DEATHS A YEAR
3-5 million new cases a year
Entire world affected

YELLOW FEVER

30,000 DEATHS A YEAR
200,000 NEW CASES A YEAR

SARS

353 DEATHS out of 5,462 cases in 180 days

ninety nine
per**cent of
in**spiration
is...

the knowledge

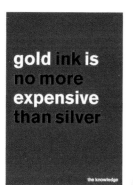

gold ink is
no more
expensive
than silver

the knowledge

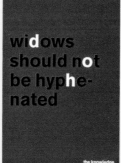

wi**d**ows
should no**t**
be hyp**he**-
nated

the knowledge

CLIENT	DESIGN
TAXI STUDIO LTD.	ALEX BANE
	RYAN WILLS
	SPENCER BUCK

TYPOGRAPHY	ART DIRECTION
RYAN WILLS	RYAN WILLS
SPENCER BUCK	SPENCER BUCK

hum**o**ur is
the s**h**ortest
distance
between
two people

the knowledge

TAXI STUDIO LTD.
THE KNOWLEDGE

Communicating Taxi Studio's knowledge of design in a witty way is part of the role of their corporate stationery. At present, 22 different statements, on 22 items of print, communicate company "knowledge" to clients. Each design, printed in two colors, uses type reversed white through a red background as a starting point. The reader cannot help but find themselves drawn firstly to this white lettering, which often highlights the subject of the quote, and then on to the complete statement, printed, with less dramatic contrast, in black on red. This work demonstrates the importance of recognizing the tonal values of colors; red is a bright, vibrant color, but it is also fairly dark tonally, enabling white lettering to contrast well with it, and black text to be clear, but not too powerful.

if you don't
see what we
mean you're
looking at
it the wrong
way round

the knowledge

Leigh Court Abbots Leigh
Bristol BS8 3RA

Call +44 (0)1275 378334
Fax +44 (0)1275 378341
Visit www.taxistudio.co.uk

taxi studio ltd

do not apply
wit **wit**h a
heavy hand

the knowledge

know the
typographic
rules
 bef**o**re
brea **k**in'
them

the knowledge

PHILIP FASS
CELEBRATION INVITATION

This entirely typographic invitation makes interesting and unexpected use of paper stock as a way of intriguing the recipient. The RSVP is the first thing the viewer sees, "so a course of action is laid out," says Philip Fass. "The text is divided into three parts: RSVP, to whom the rsvp should be sent, and the reason for the celebration. This sequence breaks up the information for the reader, while offering a rich visual experience." The metal grommet gives the reader final say over which of the three leaves of this piece they wish to prioritize.

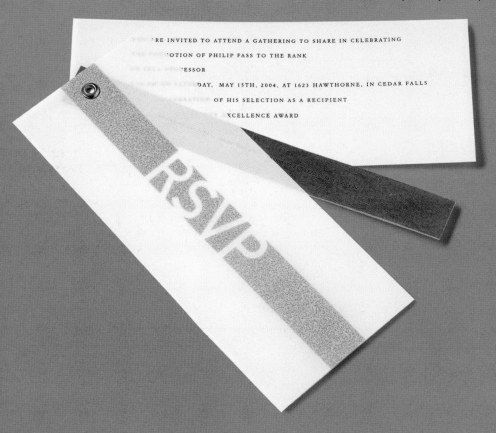

CLIENT	DESIGN	TYPOGRAPHY
PHILIP FASS	PHILIP FASS	PHILIP FASS

COPYWRITING	ART DIRECTION
PHILIP FASS	PHILIP FASS

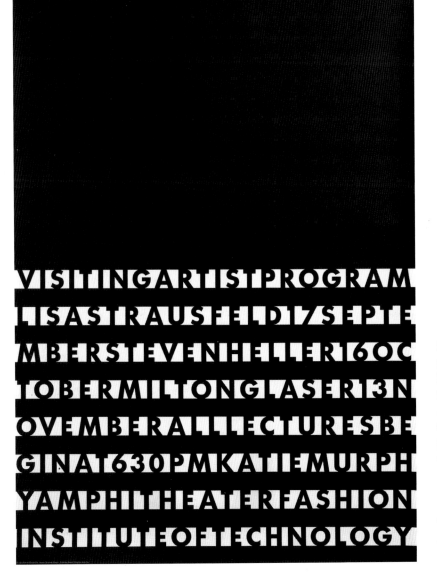

PISCATELLO DESIGN CENTRE
VISITING ARTIST PROGRAM, POSTER

This poster by the Piscatello Design Centre is particularly interesting with regard to the reader's perception. As the text is configured in capital letters, positioned on white bars, with the tops and bottoms of letterforms "bleeding" into a black background, the white counterform shapes are viewed first of all. These create a pattern that draws attention and, despite being difficult to decipher, is clearly recognizable as negative space between letters. Letterforms running onto new lines, regardless of word breaks, and without any word spacing, add to the abstract nature of the design, enabling only a persistent viewer to bring together words and shapes that form comprehensible information.

CLIENT	DESIGN	ART DIRECTION
FASHION INSTITUTE	ROCCO	ROCCO
OF TECHNOLOGY	PISCATELLO	PISCATELLO
NEW YORK	KIMBERLY	
	PISCATELLO	

« A VISION FOR THE FUTURE »

Despite the market slow down of the last few years, the pace of technological innovation remains strong. Furthermore, IT spending as a percentage of total enterprise capital spending continued to increase during the recession. The information technology industry currently accounts for approximately 5% of U.S. GDP, according to the US Department of Commerce, and is responsible for over 30% of real U.S. economic growth since 1995.

CLIENT	DESIGN	TYPOGRAPHY
DCM-DOLL	EARL GEE	EARL GEE
CAPITAL	FANI CHUNG	FANI CHUNG
MANAGEMENT		

COPYWRITING	ART DIRECTION	PHOTOGRAPHY
DAVID CHAO (DCM)	EARL GEE	GEOFFREY NELSON

A technology venture fund with a clear difference

DCM IV
DCM-Doll Capital Management

Confidential
Offering Memorandum

GEE + CHUNG DESIGN
DCM 1V OFFERING MEMORANDUM

The translucent layer of the cover for this almost A3 size (11¾ × 16½in/297 × 420mm) brochure draws the viewer into discovering the clear difference that makes DCM's technology venture fund attractive to investors. Unusual and interesting materials tend to tempt readers, making them want to "handle the goods" and enjoy the experience of touching at the same time as viewing. "The same financial symbols that appear on the cover," says Earl Gee "identify each section of the book, and function as a coding device on the right edge of each spread to guide the reader through the information." The perpetuation of the colors also draws the viewer through the pages, with selective and limited amounts of vibrant red acting as punctuation.

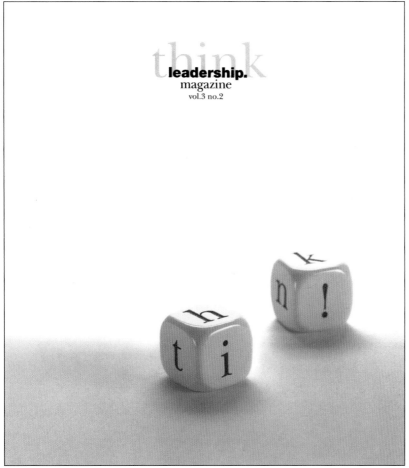

think
leadership.
magazine
vol.3 no.2

CLIENT DESIGN ART DIRECTION
IBM DOYLE PARTNERS STEPHEN DOYLE

DOYLE PARTNERS
IBM THINK MAGAZINE COVER

On the cover of this magazine for IBM, Doyle Partners took the corporate motto, "Think!" and etched the letters onto the sides of two dice. Conveying the idea of risk in a playful manner, the resulting powerful shot ensures that the reader's attention is totally captured by these two small items. This is successful because of Stephen Doyle's brave selection of small-scale imagery, his positioning it at a distance from the masthead, and his use of generous space.

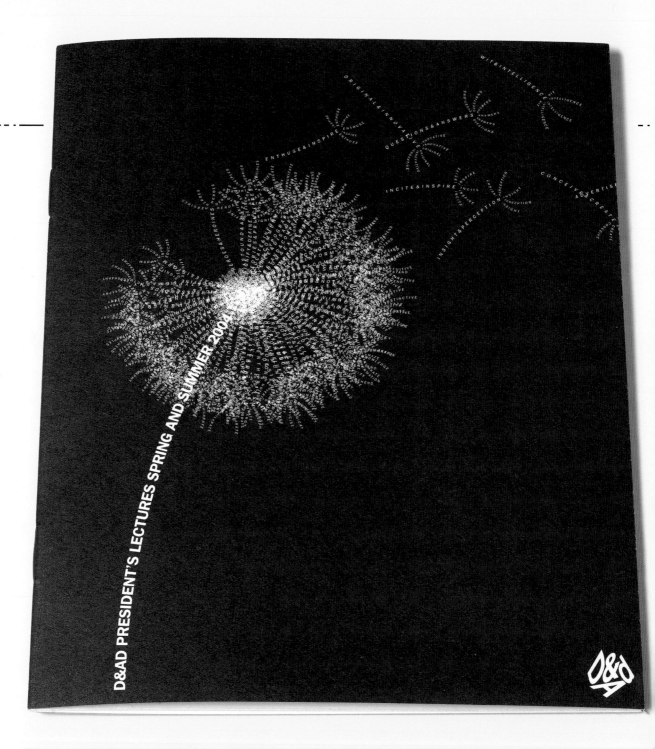

CLIENT	DESIGN	TYPOGRAPHY	ART DIRECTION
D&AD	STUART RADFORD	STUART RADFORD	STUART RADFORD
	PHIL BOLD	PHIL BOLD	ANDREW WALLIS
		FONTSMITH	

RADFORD WALLIS
D&AD PRESIDENT'S LECTURES
SPRING AND SUMMER 2004 PROGRAM

Stunning typographic illustrations flow across the cover and flaps of Radford Wallis' design for the D&AD President's Lectures program. The image of the dandelion clock and gently blowing seeds is made up entirely of lightweight, all cap text. Individual seeds are composed to make up words such as "insight," "inspire," and "enthuse." The cover, which has a glossy, yellow-coated interior, is printed on lightweight, uncoated stock. The inside pages, to contrast with this, use a weighty art board, but echo the inside cover with their subtle use of yellow. Hierarchically, the inside pages adopt the principle of proximity, discussed in Exercise Two (see page 36), to control the way information is accessed. Images, present on every spread, are printed in a light shade of gray, thus reducing their priority and impact.

CLIENT	DESIGN	ART DIRECTION
344 DESIGN	STEFAN G. BUCHER	STEFAN G. BUCHER

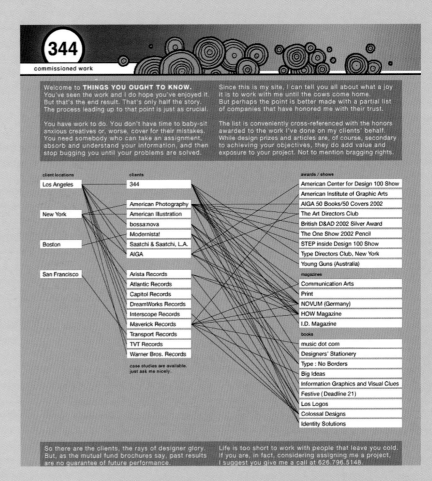

344 DESIGN, LLC
344 WEB SITE (FAQ PAGE)

Within the FAQ page of his Web site, Stefan G. Bucher needs to convey a large amount of complex information. "The client and awards graph shows that 344 has many prestigious clients, in many prestigious cities, and that the work for those many prestigious clients has won many prestigious awards," says Stefan. "In this context it's not important which piece won what," he continues, "it's the overall mass that has to be conveyed right away."

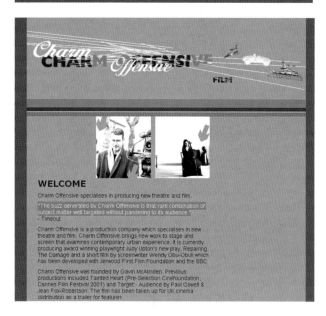

CLIENT	DESIGN	TYPOGRAPHY
GAVIN MCALINDEN	RACHEL COLLINSON	RACHEL COLLINSON

ART DIRECTION	ILLUSTRATION
RACHEL COLLINSON	RACHEL COLLINSON

RECHORD
CHARM OFFENSIVE WEB SITE

rechord were given a very open brief for this Web site for Charm Offensive. "Due to time constraints, we decided to use all of the text given and simply highlight important comments about the work in a strong color. This is also reflected in the navigation, which essentially says, 'these are the most important things you need to know about,' to our impatient Web audience," says Rachel Collinson. "Hovering over the monopoly pieces at the top—legend has it that these came from a charm bracelet—picks out letters in the Charm Offensive title, making up words that hint at key themes in McAlinden's work. The logo itself is repeated in two different fonts, reflecting the schizophrenic nature of the company name. The arrows surrounding the logo are animated in waves of attack, and are also sprinkled across the photographs used in the site, deterring any unauthorized reproduction," she concludes.

PROXIMITY, CONTINUANCE, AND SIMILARITY

Appreciating some of the basics of visually sequencing information can be extremely valuable. However detailed or sophisticated a design might be, basic principles of scale, composition, and spatial distribution are still undoubtedly applicable. In this series of exercises, the parameters of each section steadily expand to produce more complex outcomes. The emphasis is consistently upon the hierarchical structures, esthetics, and organizational systems.

There are three main principles of organization that significantly control the reading order of a layout: similarity, proximity, and continuance. Although these factors have relevance for imagery as well as type, they are particularly appropriate in the context of language and typography. Similarity relies upon a number of elements of similar visual appearance being perceived as having a common association. For example, type that has a similar weight, color, or scale, despite being dispersed across a page, will be seen as having a definite connection. Proximity is dependent upon compositional structures; when elements sit closely together, even though there may be a variety of weights, colors, and scales present, they are recognized as having a common connection. Implicit in this principle is the need for a certain amount of space to frame groupings of information. Continuance builds linear tracks in layouts to steer the reader through the text. Once again, variations of scale, color, and weight do not necessarily have an overriding effect upon the successful implementation of this principle.

11 June - 8 July

Millennium Gallery
Millennium City Building
University of Wolverhampton
Wolverhampton WV1 1SB
T: 01902 321000

An exhibition celebrating the work
of students of the School of
Art and Design, The University
of Wolverhampton,
in collaboration with local schools

Admission free

Glittering Spires

FIG. I

In fig. 1, only one typeface, weight, and point size have been used, forcing the layout to rely on composition. Groupings break the information into digestible amounts; a change of orientation prioritizes the most important facts, while the generous space in particular areas adds emphasis. A consistent approach to distances between elements creates overall coherence.

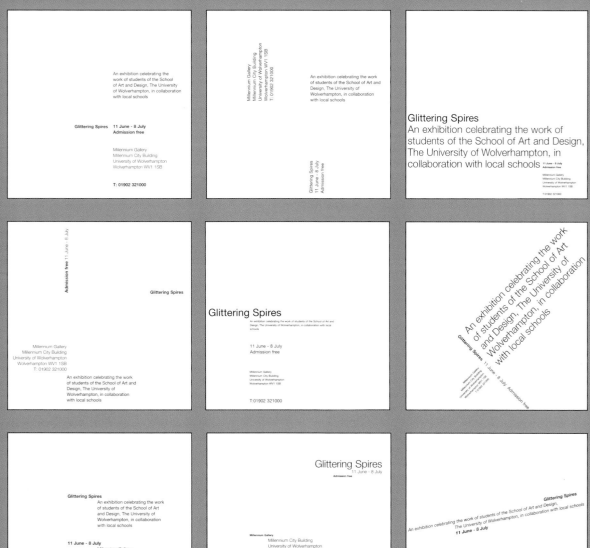

FIG. 2

FIG. 3

FIG. 4

Fig. 2 demonstrates the principle of similarity in its most simple form, using one typeface, three weights, and one point size. Even though the bold type is separated by a number of lines of lighter text, the reader is drawn to each section of bold type in turn, before going on to access the remaining copy.

Fig. 3 is an example of the hierarchical power made possible by the principle of proximity. Each typographic group utilizes a variety of different interpretations, and as a result of proximity, is accessed as a separate section of information. As a consequence, the viewer will complete one section before moving on to the next.

In fig. 4, in spite of the combined varieties of weight and scale, the type is structured to form a linear force that guides the reader along the extent of each angled pathway.

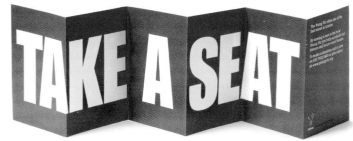

CLIENT
THE YOUNG VIC

DESIGN
HENRY WHITE

COPYWRITING
REBECCA FOSTER
HENRY WHITE
DAISY DRURY

ART DIRECTION
REBECCA FOSTER

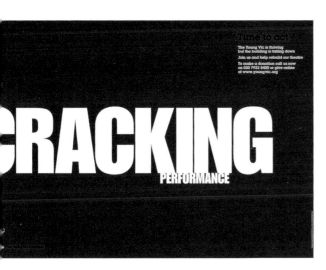

REBECCA FOSTER DESIGN
THE YOUNG VIC CAMPAIGN

The aim of the campaign for the Young Vic theater was to bring a greater awareness of the theater's desperate need for rebuilding, despite the increasing success of its performances. This objective was achieved in several ways. Firstly, the reader's attention is drawn to the large headline, which above is "cracking", and thus expresses the theater's demise. The reader is then drawn to the second word, "performance." "The combined words are taken directly from theatrical language, thus bringing together both the negative and positive situation that the Young Vic finds itself in," explains Rebecca Foster. "The third layer of text under 'Time to act' is a direct call to action," she concludes.

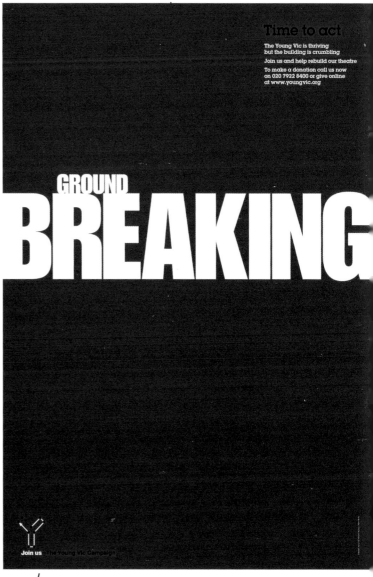

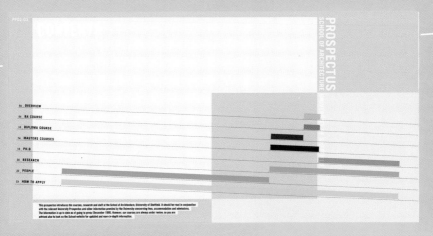

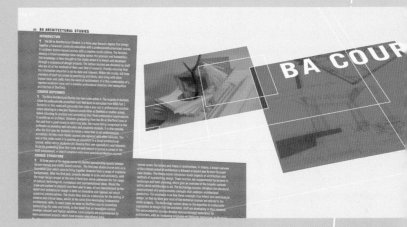

CLIENT	DESIGN
SHEFFIELD	DOM RABAN
UNIVERSITY	

TYPOGRAPHY	ART DIRECTION
DOM RABAN	DOM RABAN

EG.G
SHEFFIELD UNIVERSITY SCHOOL OF
ARCHITECTURE PROSPECTUS

Hierarchies are relative in every sense, and although the typography within this design is not particularly dominant, because the context is a prospectus, the viewer focuses on the text. Changes in the angles and orientation echo the structural nature of architecture, and blocks of color, based on a grid derived from Fibonacci rectangles, are seen predominantly as "vehicles" for type.

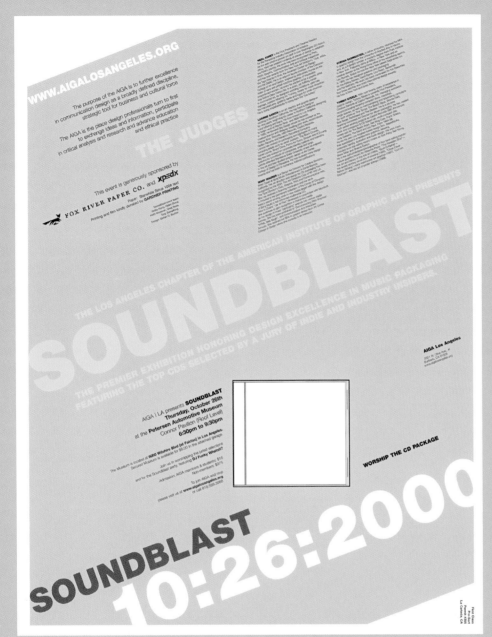

SOUNDBLAST

SOUNDBLAST
10:26:2000

WORSHIP THE CD PACKAGE

344 DESIGN, LLC
AIGA LOS ANGELES SOUNDBLAST
EXHIBITION POSTER

Making use of three-color print, this poster for Soundblast, an exhibition of entries in the AIGA competition for CD cover design, dramatically captures attention and emulates the effect of different levels of music. Type runs upward at an angle, evoking pitch and volume, with large, all cap headings being the first point of focus. The largest instance of the heading "Soundblast" is captured in light yellow and positioned upon a slightly darker yellow background; whether it is perceived as letterforms or space, the yellow acts as visual glue to hold all the elements together, and ensure that they are read.

CLIENT	DESIGN
AIGA LOS ANGELES	STEFAN G. BUCHER

TYPOGRAPHY	ART DIRECTION
STEFAN G. BUCHER	STEFAN G. BUCHER

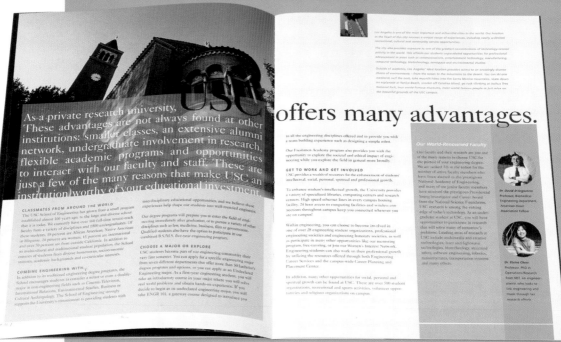

IE DESIGN + COMMUNICATIONS
USC SCHOOL OF ENGINEERING VIEWBOOK

The USC School of Engineering viewbook is a 32-page, full-color brochure that, to quote Ted Cordova of IE Design, "breaks down a massive amount of content, and creates a typographical hierarchy that organizes this content effectively." Designer Marcie Carson has derived a flexible, six-column grid that functions in varied and interesting ways. Using a mix of serif and sans-serif type, pages have a lively, interesting, and accessible feel that encourages the reader to select small, highlighted areas of information, and to dip in and out of copy. Images obviously play a significant role in these pages, but many have been carefully subdued and knocked back, with the aid of tinted panels.

Outside the Classroom

As an ENE student, you may have the opportunity to work with faculty on research projects encompassing areas such as the treatment of contaminated soils, the development of environmental engineering biotechnology for air and water purification, the utilization of energy in an environmentally safe manner, the transport and migration of pollutants in the oceans and the atmosphere and assessing effects of air pollutants on public health. Recently, ENE students worked on projects like Groundwater Decontamination Using Integrated Microfiltration Biofilm Technology and Predicting the Environmental Costs of New Products.

You also have the opportunity to participate in the USC student chapter of the American Society of Civil Engineers (ASCE). Throughout the year, ASCE sponsors a number of activities such as barbecues, luncheons and student-faculty retreats where you can get to know your fellow students and faculty outside of the classroom. A favorite activity among the students is a trip to the annual ASCE Pacific Southwest Regional Conference where you can compete in a steel bridge model construction contest, race a concrete canoe or submit an essay for a technical writing competition. Many of our ENE students are also actively involved in Student Action for the Environment (SAFE), a student organization dedicated to educating students about environmental concerns, getting students involved in cleaning and protecting our environment, and addressing political environmental issues both on and off campus.

Environmental Engineering

Environmental engineers enhance our quality of life. They treat and properly dispose of environmental pollutants, develop techniques for improving our air, water and soil quality, oversee resource recovery and recycling methods, create "green technologies" used in consumer products and manufacturing, and administer environmental regulations to ensure the safety of humans and the protection of nature's ecosystems.

CURRICULUM

During your first two years as an Environmental Engineering student, you will study the fundamental aspects of science as well as the principles of environmental engineering. In your first semester, you will take an Introduction to Environmental Engineering course that will cover the basic concepts of environmental engineering as well as the scientific, social, legal and political aspects of environmental issues and pollution control technology. Other courses you will take as a freshman and sophomore include Introduction to Environmental Engineering Methodology, Statics, Introduction to Computer Methods in Civil Engineering, Environmental Engineering Principles and Environmental Fluid Mechanics.

In your junior and senior years, you will learn about more specific aspects of Environmental Engineering like atmospheric pollution control, water and wastewater engineering, chemical and biological remediation for air, water and soil, environmental microbiology, bio-remediation and biotechnology, environmental laws and regulations, and conservation of natural resources. You also have the opportunity to focus your upper-division electives on air pollution control, water and wastewater, or hazardous and solid wastes engineering.

MAJOR EMPHASES AND OPTIONS

Environmental Engineering (Biotechnology)
The biotechnology emphasis will provide students with a background in scientific and engineering concepts and applications that will aid students in an understanding of approaches to improving the quality of the environment and solving environmental problems. Students will be introduced to concepts related to genome classifications, recombinant DNA techniques, biochemical reaction mechanisms, biochemistry principles and enzyme chemistry.

MINORS

Environmental Engineering
The minor program in Environmental Engineering will provide you with a basic knowledge of our environment, the potential causes of its deterioration, methods to prevent or mitigate environmental hazards and the means to improve its quality at reasonable costs. You will take courses like Environmental Chemistry, Environmental Fluid Mechanics, Water Chemistry and Analysis, and Environmental Quality Control and Management: A Global Approach.

The average American contributed 1,570 pounds of solid trash to the world last year, along with 23 tons of hazardous waste and 3,813 pounds of sewage.

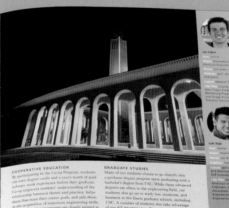

Exploring Your Future

USC is a premier research institution that also values the importance of providing students with meaningful hands-on professional experience related to their chosen field of study. Additionally, we are not only committed to helping our students succeed during their time in college, but we are also dedicated to providing resources that will assist students with their postgraduate plans.

ENGINEERING CAREER SERVICES

The School of Engineering provides extensive career services to its students. Students are encouraged to register with Engineering Career Services their first year at USC. By doing so, they will be kept informed of all career-related events throughout the year, such as company-sponsored information sessions, industry luncheons, alumni networking functions and professional workshops. In addition, students are able to participate in the School's on-campus interview program, the annual Engineering Career Conference and semiannually Engineering Career Expos.

USC's School of Engineering attracts employers not only from Southern California, but from across the country as well. A few of the companies that have recently hired Co-ops, interns and permanent employees from USC Engineering include, among many others:
• Accenture
• Boeing
• ChevronTexaco
• ExxonMobil
• Hewlett Packard
• IBM
• Intel
• Jet Propulsion Laboratory (JPL)
• Lockheed Martin
• Microsoft
• Motorola
• Northrop Grumman
• Raytheon
• Silicon Graphics
• Teradyne
• Walt Disney Imagineering
• And more....

ENGINEERING CAREER CONFERENCE

Every year, USC engineering students have the opportunity to attend a one-day Engineering Career Conference where they can participate in career-related workshops and network with industry representatives and alumni. Workshop topics include resume writing, preparing for a technical interview, mock interviews, dress for success and negotiating an offer.

ENGINEERING CAREER EXPO

Twice a year (once in the Fall and once in the Spring), the School of Engineering hosts an engineering career fair. Numerous companies participate in the Career Expos to recruit engineering students for Co-ops, internships and full-time positions.

COOPERATIVE EDUCATION

By participating in the Co-op Program, students can earn degree credit and a year's worth of paid industry work experience before they graduate. Co-op improves students' understanding of the relationship between theory and practice, helps them fine-tune their career goals, and aids them in the acquisition of important engineering skills. Students' work assignments are closely related to their specific degree program and are appropriate to their current academic level.

Participation in the program is open to all full-time undergraduate engineering majors. However, students are usually first eligible to apply for a Co-op during the second semester of their sophomore year.

ON-CAMPUS INTERVIEWS

Many engineering-related companies participate in the USC On-campus Interview Program, allowing students to interview for Co-ops, internships, and full-time jobs without having to leave campus. Students are able to register online for the On-campus Interview Program as early as their freshman year.

GRADUATE STUDIES

Many of our students choose to go directly into a graduate degree program upon graduating with a bachelor's degree from USC. While these advanced degrees are often in the engineering field, our students also go on to study law, medicine, and business at the finest graduate schools, including USC. A number of students plus take advantage of our 4/1 programs (our five-year combined engineering Bachelors and Masters programs).

CLIENT
USC SCHOOL OF ENGINEERING

DESIGN
MARCIE CARSON

43
TYPE DRIVEN

CLIENT	DESIGN	TYPOGRAPHY
THE WIRE MAGAZINE	KJELL EKHORN, JON FORSS	KJELL EKHORN, JON FORSS

ART DIRECTION	PHOTOGRAPHY
KJELL EKHORN, JON FORSS	MAGDALENA BLASZCZUK

Founded nine years ago in response to bad European attempts to mimic Anglo-American rock, Austria's Mego label have helped define the growth of experimental electronica in the 90s and beyond. In Vienna, Edwin Pouncey meets the label's inner circle, Ramon Bauer, Tina Frank and Peter Rehberg, to hear about the label's past, present and future. Photos: Magdalena Blaszczuk

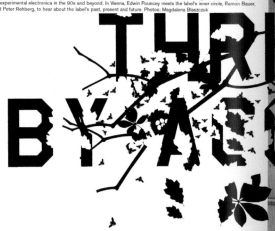

42 THE WIRE

PETER REHBERG (TOP) AND HECKER IN VIENNA, MARCH 2

NON-FORMAT
MEGO LABEL MAGAZINE SPREAD

Using bold, centered, illuminated letters for the heading of this spread for *The Wire* magazine, Kjell Ekhorn and Jon Forss have commanded the viewer's attention. Although 50 percent of this spread features an allover image, the reader is drawn to the heading first because the shot, captured from an interesting angle by Magdalena Blaszczuk, has slightly lighter tonal values and the detailing of the lettering is so unusual and unexpected. Three long lines of small text on the left-hand page make up the third level of this "sandwich."

MUGGIE RAMADANI DESIGN LAB
REBEL HAIRDESIGN IDENTITY

Heavily outlined, Gothic-style type forms the basis of Muggie Ramadani's new identity for Rebel Hairdesign. A surprising mix of yellow, green, gray, and black has been carefully selected to ensure that the company namestyle is always seen first, even when placed on top of Mikkel Bache's color photography.

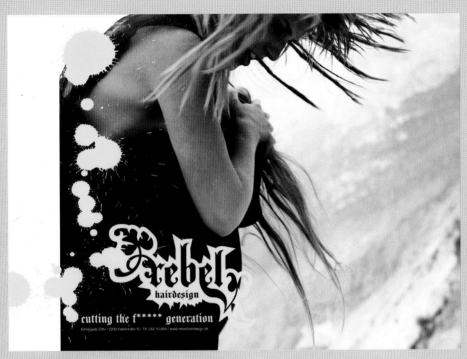

CLIENT	DESIGN	TYPOGRAPHY	COPYWRITING	ART DIRECTION	ILLUSTRATION	PHOTOGRAPHY
REBEL HAIRDESIGN	MUGGIE RAMADANI	MUGGIE RAMADANI	LARS WILLADSEN	MUGGIE RAMADANI	MUGGIE RAMADANI	MIKKEL BACHE

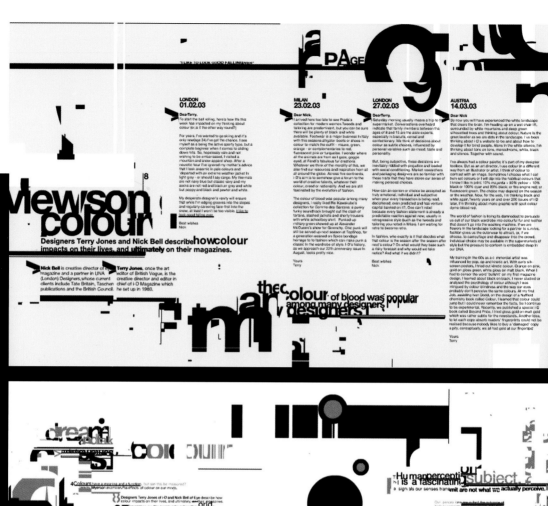

MATEEN KHAN DESIGN
DREAM AND TALK

A single, strong, bright color, working in tandem with black and white, makes each of these pages visually dynamic and eye-catching. Type is configured as text and image, and is predominantly in black, making the large-scale letterforms extremely powerful and inviting. Because certain large letterforms come together to form recognizable words, the reader expects all the sections of letters and graphic shapes to have meaning; as a consequence they entice the eye around the spread and into the copy.

CLIENT
SELF-PROMOTIONAL PROJECT

DESIGN
MATEEN KHAN

FISHTEN
NEW PAINTINGS EXHIBITION
CATALOG

"A white-on-white typographic concept has been chosen to mimic the architecture within the gallery," says Giles Woodward of Fishten's design for the Robert McLaughlin Gallery. "Light, shadow, dimension, and space are created by the use of gray ink, clear foil, gloss varnish, and blind embossing," continues Kelly Hartman. This ensures that, following the wishes of the artist, Gary Spearin, the function of the installation is present within the catalog. "Hierarchies were developed by mixing special effects together to create coded information, a concept also inherent within the artist's work," concludes Hartman.

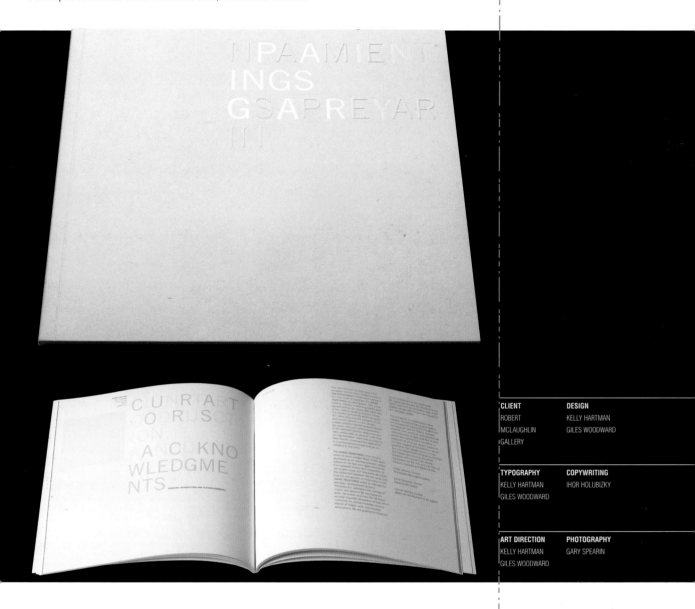

CLIENT	DESIGN
ROBERT MCLAUGHLIN GALLERY	KELLY HARTMAN GILES WOODWARD

TYPOGRAPHY	COPYWRITING
KELLY HARTMAN GILES WOODWARD	IHOR HOLUBIZKY

ART DIRECTION	PHOTOGRAPHY
KELLY HARTMAN GILES WOODWARD	GARY SPEARIN

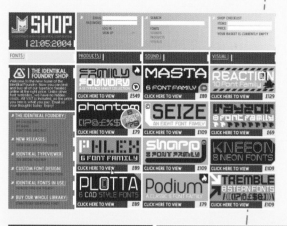

IDENTIKAL
IDENTIKAL SHOP

The Identikal shop, designed by Identikal's Adam and Nick Hayes, is a colorful, animated Web site that comprehensively showcases these identical twins' contemporary type designs.

The Home page banner allows the visitor access to the four main areas of the shop: fonts, products, sounds, and visuals. This banner, teamed with the strong, iconic namestyle for the shop, plus log-in and search options, has a constant dominant position at the top of each page.

The site expands to reveal a fascinating, tantalizing mix of typeface samples, many shown using a limited palette of two colors. Each face has a clear identity of its own which, with the aid of clever animation, calls out to be viewed in direct competition with its neighbor.

CLIENT	DESIGN	TYPOGRAPHY	ART DIRECTION
IDENTIKAL	ADAM AND	ADAM AND	ADAM AND
	NICK HAYES	NICK HAYES	NICK HAYES

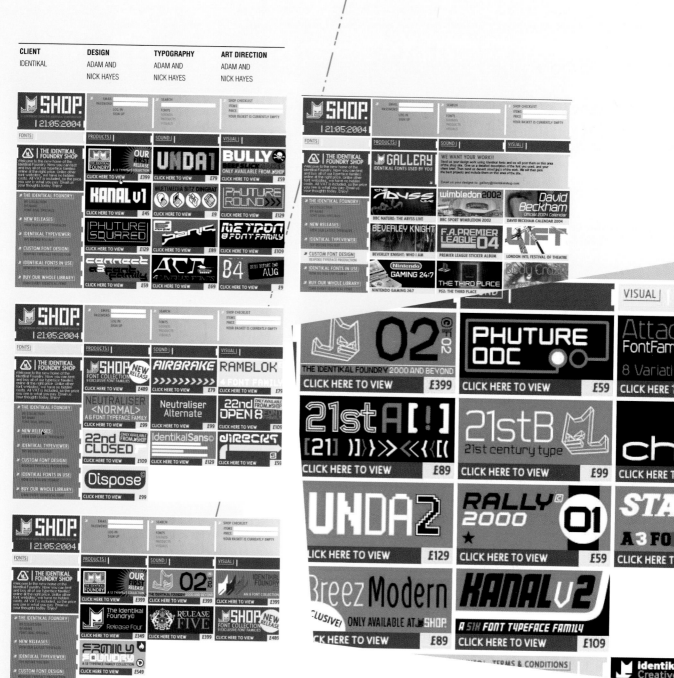

On close examination, these typographic blocks reveal a complex and expertly controlled hierarchy. Each individual box has equal priority on the page, while adopting changeable use of color, scale, and weight. Color priority is intelligently varied, but controlled to guarantee the visitor unbiased, fair access to all typefaces.

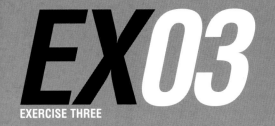

EX03

TYPE AND COLOR

Introducing color to a typographic layout can make a tremendous difference to the visual hierarchy, depending on the tonal value and vibrancy of the selected colors. Tonal values are often overlooked; in terms of attracting attention, the strongest colors are both bright in hue and comparatively dark in tone. This exercise is designed to highlight the effect of one color in relation to black, as well as a number of colors working with each other.

In order to isolate the impact of introducing color into a design, the exercise involves only three letterforms at a time, and limited parameters for each step. A restricted palette of five colors is also helpful as, although this precludes subtle nuances that would create different results, it makes constructive reference material and enables some interesting conclusions to be drawn. Three letterforms have to be selected—one from each collection, A, B, and C—and generated side by side in black Helvetica Medium, all caps. This forms a standard which is then manipulated within three different categories to produce a wealth of reference material. There are many modifications that could produce an infinite number of alternatives, but to maximize the experience of color, only changes of scale, weight, and/or juxtaposition are available, plus changes to lowercase letters.

FIG. 1

FIG. 2

FIG. 3

In fig. 1, as many variations of relationships as possible are produced, using black type with one color at a time, selected from the palette.

In fig. 2 this exercise is repeated, using black and two colors at a time, selected from the palette.

Fig. 3 demonstrates the exercise using colors only—without black—selected from the palette.

LETTER COLLECTIONS
A: B C D G J O P Q R S
B: A E F H I K L M N T V W X Y Z
C: I J M L W T F A V

Changes in color only across the three-letter combination of Helvetica Medium, all caps, establishes the significance of red in attracting attention, and also highlights the effect of tonal values in controlling the hierarchy. As changes of scale and weight come into play, the same relationships are developed and modified, but it is interesting to observe that paler colors, even when used for large, heavyweight letterforms, still do not stand out as much as comparatively small, lightweight, darker colors. Composition and scale help to defy the expectation of reading from left to right, but it is mainly the vibrancy of hue and darkness of tone that affect the order in which letters are perceived.

CLIENT	DESIGN	TYPOGRAPHY
ROCKPORT PUBLISHERS INC.	STEFAN G. BUCHER	STEFAN G. BUCHER

COPYWRITING	ART DIRECTION
STEFAN G. BUCHER	STEFAN G. BUCHER

344 DESIGN, LLC
ALL ACCESS: THE MAKING OF THIRTY
EXTRAORDINARY GRAPHIC DESIGNERS

Dramatic typography and use of scale, strong groupings, and exciting use of space epitomize the pages of *All Access: The Making of Thirty Extraordinary Graphic Designers* by Stefan G. Bucher. Bold, sans-serif, all cap headings draw the eye on most pages, providing an authoritative starting point for the viewer. A mix of cut-out and squared-up images are used within spreads, with the addition of vertical and sometimes horizontal rules to anchor these shots to the bottom of the page, and visually link them with the text.

VALERIE KIOCK

German designer Valerie Kiock has integrated her love for graphics with an ever-growing interest in furniture design to forge a unique body of work that benefits from its exposure to both worlds.

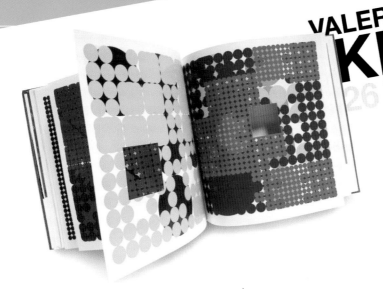

Pretty much anything goes in graphic design. As in fashion, trends remain—currents and quirky little eddies that curl away and disappear—but the authoritative party-line style of earlier times is gone. At this point it takes desire and a tight focus to learn the craft of minimalist Swiss typography. It takes a young eye, guided by immaculate taste, to use its tools to create design that is relevant and holds its own amidst the flood of dazzling, more effects-laden work. Valerie Kiock describes her approach: "Stylistically, I tend towards the pragmatic approach: legible, clear, comprehensible, well-founded, rather straight ahead, strict, but certainly neither boring nor bland. I always like to play around, figuring out what works and how it works."

CANDY AND THE CLASSICS Growing up in Munich, Valerie Kiock started collecting candy wrappers as a child, attracted by the combination of colors and typography. She remembers small chewy squares wrapped in colored paper, ringed with printed tinfoil that identified the flavor of each piece with words and picture. It didn't take long for her to form a Pavlovian connection between sugar and graphic design.

The second push toward design occurred when Kiock went to see a Raymond Loewy exhibit. "I remember the progression of the Shell logo exactly. I was intrigued by the reworking, the mutations. I remember the Lucky Strike package, of course. Beautiful to begin with, it turns from green to white for nonaesthetic reasons. The brand, the application, following a need was what interested me. You might call it 'freedom within boundaries.'" Following the exhibit, she started leafing through magazines, clipping typestyles, pictures, ads—image/type combinations, colors, and patterns—and placing them in scrapbooks. "Also packages, postcards, and stamps—everything I thought was beautiful."

1999
spherizel, chair Valerie Kiock and Kuno Nussli originally designed spherizel as a plywood lounge chair containing a big rubber ball. The production model is inflatable rotary cast plastic.

1999
The Apartments, Clerkenwell, brochure
This brochure for a development in Clerkenwell, London, where a '60s office building was converted into apartments, gave Kiock her first experience working on a project about architecture.

1999
N2, leaflet The name of the design group is derived from the highway that connects Basel and Luzern, the two cities where the designers were living. Green was taken from Swiss freeway signs.

2002
Taylor Bloxham Diary 2002 The day planner advertising the Glen's new twelve-color press was a studio collaboration at Williams & Phoa. "My section is die-cut and shows dots and flowers that use eleven special inks, including day-glo and metallic inks and a varnish."

KIM 24 HIORTHØY

Making the most of opportunities that present themselves, Kim Hiorthøy has built an eclectic but always personal body of work that includes not only graphic design and illustrations but music videos, two documentaries, and two albums of his own music.

Kim Hiorthøy was born in Trondheim, the third largest city in Norway, in 1973. "For as long as I can remember, I have always drawn. Both my parents were architects. I had no siblings, and whenever I complained of boredom, drawing utensils would be stuck in my hand. I grew up seeing a lot of buildings and art, and I spent a lot of time sitting alone, drawing or painting."

But despite immersing himself in the visual arts, his life ambition lay elsewhere. "A tremendous part of my spending so much time drawing and making things was because I didn't fit in so well socially. It wasn't something I chose. My real dream was that I would become an actor. I was intensely passionate about drama and theater and took drama classes. Drawing felt like a private thing." Then, at age sixteen, Hiorthøy felt a change within himself that shifted his interest back toward art. He can't explain what happened. All he knows is that he was ready to dedicate himself to art.

"When I began college, I chose art classes in addition to my regular subjects. The making of visual images became something more." College also provided Hiorthøy with his first chance to see his work published. "My drawing teacher was married to the editor of the biggest local newspaper. During my second year, she took my drawings to him, which lead to me getting my first job—illustrating crime novellas for the Saturday edition—when I was seventeen. I continued to do this for the next couple of years. By that time, I had begun to be seriously interested in what I understood as fine art."

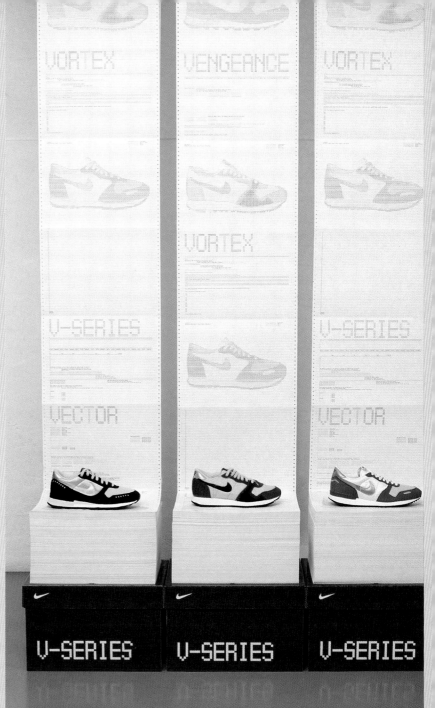

CLIENT	DESIGN	TYPOGRAPHY	ART DIRECTION
NIKE	JOE BURRIN	JOE BURRIN	TONY BROOK

SPIN
V-SERIES PACKAGING

Connecting well with eighties' style, Spin have used ASCII type and reams of computer paper to establish an identity for its V-Series trainers, first created by Nike in that decade. The typography evokes "old-fashioned" computers, and examination of these reams of paper not only provides information concerning footwear, but also line upon line of characters that come together to create images of the shoes themselves.

Chair's introduction

This last year has been eventful and, certainly memorable. The major terminal development, which was commenced some five years ago, was completed during the year and commemorated by the arrival at the airport of Nelson Mandela as part of his visit to Leeds.

Over the year more passengers than ever before have passed through the airport and in the case of the Leeds United flights a lot of passengers over a very brief period of time. Coupled with the scale of the latest development which affected all areas of the terminal building, it is a remarkable tribute to the efforts of all our staff and business partners that there were so few operational difficulties during the period.

Our profits have increased during the year, to reach a level slightly in excess of that achieved prior to the abolition of intra EU duty free allowances. I am pleased that this has enabled the Board to recommend payment of a dividend to our shareholders.

the question of whether a new airport is needed to meet the needs of the region has continued to be the subject of lively debate over the past twelve months. Whatever the eventual outcome of the Public Enquiry to scrutinise the proposals for a new commercial airport at Finningley, I am confident that Leeds Bradford will play an ever increasing role in serving the economy of the region for many years to come.

During the year the Company gave its support and commitment to a number of initiatives in the region. A new bus service now operates to Bradford and completes our aspirations for a public transport service from the city centres of Leeds and Bradford to the Airport. I would also like to mention Yorkshire Air Ambulance who now have a base at LBA and provide such a unique service in the region.

As a Company we recognise the immense opportunity and value we can add to the community by supporting educational initiatives such as A Year in Industry and the Right to Read Scheme. We also participate in a number of other educational projects including an out of school learning programme in conjunction with Benton Park High School and the UFA Summer Challenge with John Smeaton Community High School.

One of the airport's undoubted strengths is the commitment of its staff. I have been most impressed that we have been able to maintain a friendly and helpful service to passengers at a time when, behind the scenes, the airport terminal was being rebuilt. My thanks go to everyone who has made this possible. I would also like to thank my fellow Directors and the Shareholders for their consistent support over the years.

8:43AM
PUSH BACK OF AIRCRAFT
Jim of Airway Handling completes the pushback of the bmi british midland Boeing 737 destined for London Heathrow.

AIR TRAFFIC CONTROL GIVES FLIGHT BD 291 APPROACH INSTRUCTIONS 8:35AM

YORKSHIRE'S 24 HOUR AIRPORT

I am very proud to be taking over as Chair of the Board for my third term of office and I am struck by the immense changes that have occurred over the past few years, both in terms of the level of activity at the airport and the facilities that are now available to our passengers. I would like to pay tribute to the commitment shown by my predecessor Councillor Tony Cairns, under whose stewardship so much has been achieved in the past two years.

DENISE ATKINSON MBE
CHAIR OF THE BOARD OF DIRECTORS

8:00AM
AIRSIDE OPERATIONS
Peter and Steve load the baggage for the Britannia Tenerife flight.

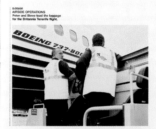

Contents

TECHNICAL STAFF 5:20AM FINAL CHECKS ARE MADE FOR THE BUSY DAY AHEAD

YORKSHIRE'S 24 HOUR AIRPORT

Leeds Bradford is a local and convenient, twenty-four hour, international airport. Although we run a global business we are still a friendly and down to earth organisation. We pride ourselves on the relationships we build with our customers, for whom we strive to give the highest quality service, and the local community who are, after all, our neighbours.

5:15AM
AIRFIELD LIGHTING ENGINEERS
Keith and Neil undertake an early morning lighting inspection on the runways and taxiways.

9:15AM
AIR TRAFFIC CONTROL TOWER
Andy is busy to the end of his night shift, controlling aircraft from the tower of the airport.

A NEW DAY BEGINS ...
LEEDS BRADFORD INTERNATIONAL AIRPORT
ANNUAL REPORT AND ACCOUNTS 2000/01

LEEDS BRADFORD INTERNATIONAL AIRPORT

BRAHM DESIGN
A NEW DAY BEGINS …,
ANNUAL REPORT

Despite strong photography, condensed, bold, all cap type is the first visual element to be seen by readers on each page of *A New Day Begins* … The central position of the title on the front cover establishes an eye level that is maintained across each spread, linking them together and ensuring that the headline type is read first. Large, bold, introductory text and a mix of full-color images are the second element seen, leaving the silver body copy and small captions to make up the final layer of this "graphic sandwich."

CLIENT	DESIGN
LEEDS BRADFORD INTERNATIONAL AIRPORT	LEE BRADLEY DAVE WATERS

TYPOGRAPHY	COPYWRITING
LEE BRADLEY	JOE COLEMAN

ART DIRECTION	PHOTOGRAPHY
LEE BRADLEY	MICHAEL FEATHER

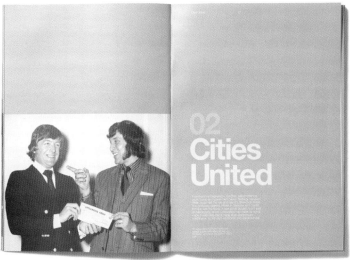

BRAHM DESIGN
FOOTBALL & FORTUNES
BOOK DESIGN

Brahm Design have adopted a strong use of color and large headings for the pages of *Football & Fortunes*. Section dividers are color coded, with color selected to tone with the hues in the photographs; this not only gives cohesion, but also takes the reader comfortably from large, dynamic expanses of color that contain the type, to similar colors in the image. Brahm have created a simple grid structure and a clear typographic hierarchy throughout, with main headings, subheadings, quotes, and body copy in two weights.

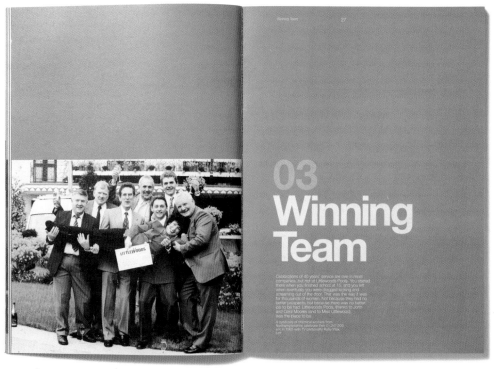

"Nothing could have prepared me for my first Saturday at the Pools. With all the post opened, hundreds of women reached for their 'Joey' machines to security stamp the coupons. The noise was thunderous."

Dorris Glauzow, who has worked at Littlewoods Pools for the past 34 years

Welcome to the computer age

The images of hundreds of women working in neat rows of desks to check and double check each and every coupon are synonymous with Littlewoods Pools, but they hide the technology that was necessary to keep pace with the growing popularity of the pools. In the late 1940s and early 1950s, there were no automated processes available to make life easier, so the weekly checking of up to five million coupons was made by more than 10,000 staff.

By the 1950s, however, advancements in technology had meant that more than seven million coupons every week could now be checked by 5,500 staff backed by an array of scanners and processors. In the five checking centres – three in Merseyside and one in both Glasgow and Cardiff – the weekly process had taken up to 30,000 man (or woman) hours, but by 1961 Littlewoods had been able to design and commission the first of 24 high speed optical scanners for its checking centres that cut the work to a fraction of the time. Five coupons could be checked every second. Even for the complicated permutations on the coupons, a computer print-out made checking relatively easy compared to the good old days.

Millions of customer addresses stamped onto separate stencils – and taking up thousands of square feet of storage space – were replaced in 1964 by magnetic tapes capable of holding more than 200,000 addresses on each tape. Back in 1966, Littlewoods became one of the computer pioneers when it installed an IBM 360 system, one of the most advanced at that time and able to cope with the customer database of over 10 million people.

A year later, Littlewoods became the first company in the UK to install an optical character reading machine that allowed client coupons to be identified through a special code printed on each envelope.

A typical coupon-checking shift at Walton Hall Avenue. Right

04 Millionaire Maker

Winning lines

CLIENT	DESIGN	TYPOGRAPHY
LITTLEWOODS POOLS	PENNY LEE	PENNY LEE LEE BRADLEY

COPYWRITING	ART DIRECTION
PHIL READ	LEE BRADLEY

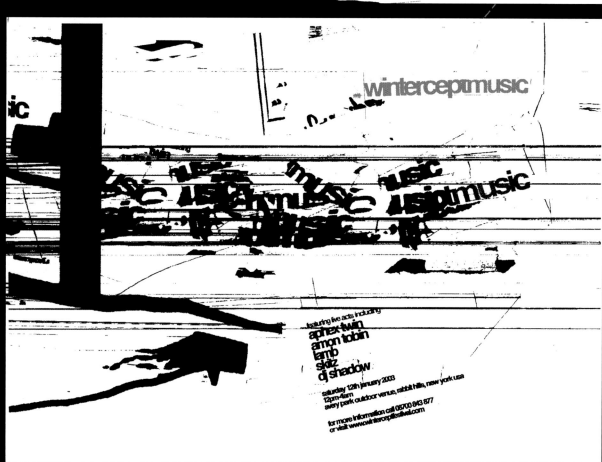

CLIENT	DESIGN	TYPOGRAPHY	ILLUSTRATION
SELF-PROMOTIONAL PROJECT	MATEEN KHAN	MATEEN KHAN	MATEEN KHAN

MATEEN KHAN DESIGN
WINTERCEPT MUSIC FESTIVAL POSTERS

Mateen Khan has used typography as the predominant feature in these posters for a music and snowboarding festival to try to capture the exciting speed, action, and culture associated with the sport. In a sense, the type borders on image, but because there are no figurative elements, the viewer can only bring the letters together to make words. The secondary text then becomes a natural progression.

MIRKO ILIC CORP.
MOVING CARD

A palette of orange, yellow, and green vellum immediately entices the viewer to look more closely at this unusual yet simple moving card created by Mirko Ilic. A repeated L shape, which is the Levy Creative Management logo, is recognized next, as form and counterform interact with each other. Black type then anchors the piece, confirming its purpose. The mixing of colors in each announcement, and the movement of the Ls in their envelopes, provide an additional and final level of experience that leaves the viewer with a sense of fun and spontaneity.

CLIENT	DESIGN	ART DIRECTION
LEVY CREATIVE MANAGEMENT	MIRKO ILIC HEATH HINEGARDNER	MIRKO ILIC

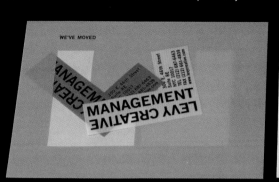

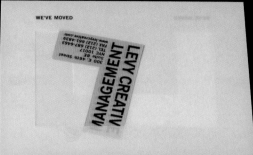

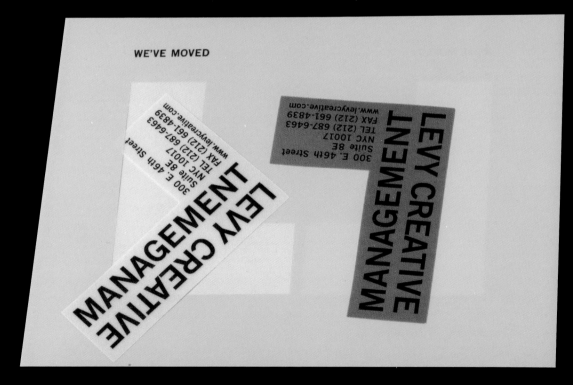

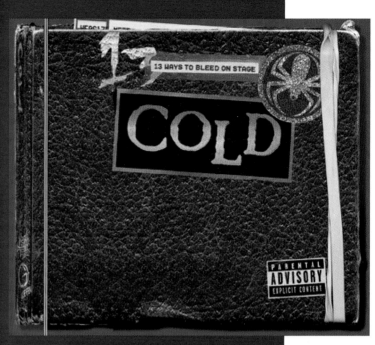

344 DESIGN, LLC
13 WAYS TO BLEED ON STAGE
CD COVER, COLD

This entirely collaged design by Stefan G. Bucher of 344 Design evokes the quality of a well-used scrapbook with a decorated cover. The name and logo of the band are shown as stickers, and all supporting text and information appear as separate, glued-down pieces; these attract attention in varying degrees. All type styles have been carefully selected to produce a deliberately convincing amateur style, and yet it is clear that the hierarchy is professionally controlled, and totally appropriate for "someone obsessed with blood," says Stefan.

CLIENT	DESIGN	TYPOGRAPHY	ART DIRECTION
GEFFEN RECORDS	STEFAN G. BUCHER	STEFAN G. BUCHER	STEFAN G. BUCHER

FISHTEN
BLIND STAIRS EXHIBITION CATALOG

Fishten have created an instantly evident staircase effect with their unusual format for this catalog for the exhibition Blind Stairs. Divided into three sections, imagery is restricted to the bottom step, while biographies and essays are accommodated within the pages of the upper two steps. The cover takes its theme from the concept of blindness; the hierarchy is controlled through the use of two colors of similar tone that make the text less distinct, and by partially obscuring the typography. Interestingly, although the partially seen type says something about the experience of being blind, from a reader's point of view, it also attracts attention because it is unusual. Inside, text-rich pages gain impact through the use of single colors—red and blue—printed on pale stock, and headings develop the blind theme by being partially obscured along an angled baseline.

CLIENT	DESIGN	TYPOGRAPHY
SOUTHERN	GILES WOODWARD	GILES WOODWARD
ALBERTA	KELLY HARTMAN	KELLY HARTMAN
ART GALLERY		

COPYWRITING	ART DIRECTION	PHOTOGRAPHY
EMILY FALVEY	GILES WOODWARD	ANDY PATTON
SOPHIA ISAJIW	KELLY HARTMAN	JOHN DEAN
		J. RINGUETTE
		EDMONTON ART
		GALLERY
		PETER MACALLUM
		CHRIS THOMAS
		KEVIN BAER

Acknowledgements

The idea of Blind Stairs began with Janice Gurney, Mary Scott and Arlene Stamp. As Janice explained in a letter, *Arlene, Mary and I feel we are at similar points in our lives as artists. All of us are revisiting our past work and remaking it in some way that alters its original form and content.* The exhibition grew from the rather open proposal assembled by the artists in 2001, and became the travelling group retrospective that opened in Halifax, and later in Lethbridge, in 2003. We have kept the original title, *Blind Stairs,* which the artists arrived at jointly, and also the emphasis on patterns of appropriation that mark their conception of artistic authorship.

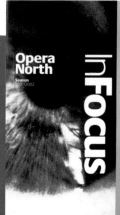

We're doing Opera North.

New voices

Opera North's Education Department runs a programme of work throughout the north of England, involving young people and teachers from primary, secondary and special needs schools, FE and HE Colleges and local community groups.

In my dreams
Blue - Green - Red - Silver
The fair - Forest
In my dreams I fight a horse,
In my dreams I ride a whale.
Blue - Green - Red - Silver.

In the forest
Climb a tree.
Chop it down.
Birds singing,
in the trees.
Tree's whistle.
Snow falling.
Play and leap
about.

Milky Way and
currant bun stars
twinkle, and a
moon made out
of swiss cheese.

CLIENT	DESIGN
OPERA NORTH	LEE BRADLEY
	DAVE WATERS

TYPOGRAPHY	ART DIRECTION
LEE BRADLEY	LEE BRADLEY

BRAHM DESIGN
INFOCUS MAGAZINE

This issue of *InFocus* magazine has been created for Opera North by Brahm Design. The pages highlighted here have a typographically driven emphasis; bold, upper- and lowercase headings are seen first, with introductory statements and large quotes following on. Lee Bradley and Dave Waters have also made bold use of color, with boxes and half pages containing bright tones that attract attention.

The voice
of Verdi

by Leoš
Janáček

The Cunning
Little Vixen

WARHOL

ANIMALS

19.05 —
15.06.04

24.06 —
11.09.04

Catalogue available

Catalogue available

6 Haunch of Venison Yard
off Brook Street
London W1K 5ES
England

T +44 (0)20 7495 5050
F +44 (0)20 7495 4050
info@haunchofvenison.com
www.haunchofvenison.com

SPIN
HAUNCH OF VENISON GALLERY
WARHOL AD

Different relationships
of color and tone vie for
supremacy in this Spin ad.

Orange tends to be a powerful and dominant hue, and
contrasts comparatively strongly with black; however, as
black type on a white background produces the ultimate
contrast of tone, this is likely to be more prominent.

CLIENT	DESIGN	ART DIRECTION
HAUNCH OF VENISON GALLERY	TONY BROOK	TONY BROOK
	JOE BURRIN	
	TOM CRABTREE	
	HUGH MILLER	
	DAN POYNER	
	IAN MCFARLANE	

Fig. 1 shows the use of comparatively simple design devices to encourage the viewer to continue on through all of the copy. Bold headlines attract attention initially, then the bold, exdented start of each paragraph, together with small sections made bold for emphasis, draw the viewer through the text.

Fig. 2 uses white type on black boxes to create a strong second level. Gray highlighting, imitating the use of a highlighter pen, emphasizes random areas and entices the reader back into the bulk of text repeatedly. Compositionally, the black boxes lead in from the left, down to the base of the layout, and finally off to the right, persuading the reader to absorb all the text "en route."

Fig. 3 introduces typographic variations that make the middle levels of information quite challenging for readers. Close leading, changes of orientation, reversals of white through gray, and black on gray create a more interactive environment that tempts the viewer to delve deeper.

In each layout, white space, paragraph and line spacing, and gutter widths are all used to determine the paces and rhythms that help to maintain the reader's attention.

SEQUENCING QUANTITIES OF TEXT

Large quantities of type can be daunting if designers do not take responsibility for breaking information down into different levels and groupings. This exercise gives you the opportunity to explore various ways of providing the reader with at least three levels through which to access information: initial headline copy to take in at a glance, a second level that elaborates to some degree but can still be absorbed fairly quickly, and a third level that fills in details.

Unfortunately, the middle layer is frequently omitted or underplayed. This exercise encourages the handling of this "middle" section so that it not only leads the submissive reader through the text in a set order, but also holds the attention of more resistant viewers, and keeps drawing them back in. Working with the same text each time, produce a broad range of alternative A4 (8⅛ × 11¹¹/₁₆in/210 × 297mm), double-page layouts that include at least three levels of information. Priorities do not need to change, although they can, but the ways in which these priorities are achieved must show variety.

FIG. 1

TYPOGRAPHICALLY DRIVEN
HIERARCHIES

EXAMINING THE FASCINATING AND COMPLEX REALMS OF HIERARCHIES THAT ARE TYPOGRAPHICALLY EXPRESSED

Typographic hierarchies are predominantly governed by relationships of texture and tone. Letterforms, words, and lines of type come together to form different tonal values as well as varying characteristics of patterning; depending upon the darkness of tone generated, together with the scale and nature of texture, a viewer is attracted to a greater or lesser degree. Choices of typeface, point size, tint, weight, tracking, line spacing, and general spatial distribution affect the density of the type, and consequently, create differing degrees of light and dark. Similarly, these distinguishing characteristics impact upon the kind of pattern that is made. However, when composing differing varieties of texture and tone, designers should be prepared to make visual judgments. Logically or incrementally based changes can be a good place to start, but will not necessarily result in sufficient, meaningful change or noticeable visual difference.

Position and orientation within a layout have far less significance than density of texture and darkness of tone; key information will still be recognized as having primary importance wherever it is located, providing that it has sufficient intensity. As far as the sequencing of subsequent information is concerned, ever-decreasing tonal values will operate in tandem with Western conventions of reading from left to right and from top to bottom. Designers impose structures and style, but must always recognize Western viewers' instinctive response to return to the left edge, and to "work their way down" a layout.

POSITION AND ORIENTATION WITHIN A LAYOUT HAVE FAR LESS SIGNIFICANCE THAN DENSITY OF TEXTURE AND DARKNESS OF TONE; KEY INFORMATION WILL STILL BE RECOGNIZED AS HAVING PRIMARY IMPORTANCE WHEREVER IT IS LOCATED, PROVIDING THAT IT HAS SUFFICIENT INTENSITY.

It is important to recognize that all typographic tonal and textural qualities are relative, both to each other and to the supplementary text and image on the page. Composition inevitably has a powerful influence; space around type will set it apart and give it more prominence. For example, large, bold, black, sans-serif type is not necessarily more evident or powerful than small, lightweight lettering. If the black type fills an area and bleeds off at the parameters of the page, then the reader is likely to interpret the text as image; position the smaller information in the remaining generous space and the reader's attention will almost certainly be drawn to it. Add the option of reversing type through a black box and the smaller, lighter copy takes on an even greater significance and impact. Imagery, in close association with type, can also make it possible to mute the impact of bold, large, black copy. When letterforms overlap imagery of a similar tone, or intertwine with images, they become less like parts of words, and more significant as shapes within the picture content.

In considering the role of type as a regulator and controller of hierarchies, it is necessary to keep in mind that letterforms make words and words have meanings. Scale, tone, and texture are always going to be relevant, but the actual words that are used also have influence. For example, highly topical subject matter, challenging language, and shocking statements are more likely to attract attention, even when represented with little dynamism. These comments apply to situations such as subheadings and main headings, but also to words and phrases that can jump into the focus of the reader from within paragraphs. Looking at the example shown, it is likely that the meanings of the highlighted words, as well as the emboldening, add to their salience.

Choices of typeface can also influence the ordering of typographic information. For example, certain families are associated with expected contexts and levels of priority. A word generated in bold, sans-serif type, all caps, may well create a strong texture and tone, but it can also have connotations of warning signs, severity, and importance, and therefore manifest more significance within a layout. Conversely, a complex or decorative typeface creating a very similar texture and tone on the page might well attract the reader initially, but because the text is difficult to read, an audience is likely to quickly move on to more accessible words. Some typefaces encompass more subjective interpretations, having personal associations or familiarity, and this too can impact upon progression, whether to attract or deter.

The inclusion of color in a layout brings another dimension, another modifier, to the ordering of visual data; luminosity and vibrancy are enticing; softer, paler colors appear to be knocked back; certain colors have connotations that provide meaningful relevance; small amounts of color act as highlighters. However, within the numerous roles that color can play in terms of hierarchy, one particular characteristic should not be overlooked, and that is the tonal value. Once again, it is not merely the hue that needs to be selected appropriately, but also the tone. Viewing colored typographic relationships in grayscale gives an excellent indication of prominence and priority. If color lasers function correctly when viewed in grayscale, they will certainly be equally strong in color.

As with all principles of design, those presented here serve merely as general rules and guidelines; there are no definitive dos and don'ts. The following pages in this section look at examples and exercises that demonstrate some of the intricacies, fine balances, and anomalies that designers face when creating visual hierarchies.

IN CONSIDERING THE ROLE OF TYPE AS A REGULATOR AND CONTROLLER OF HIERARCHIES, IT IS NECESSARY TO KEEP IN MIND THAT LETTERFORMS MAKE WORDS AND WORDS HAVE MEANINGS.

Typographic hierarchies are predominantly governed by relationships of texture and tone. Letterforms, words, and lines of type come together to form different tonal values as well as varying characteristics of patterning; depending upon the darkness of tone generated, together with the scale and nature of texture, a viewer is attracted to a greater or lesser degree. Choices of typeface, point size, tint, weight, tracking, line spacing, and general spatial distribution affect the density of the type, and consequently, create differing degrees of light and dark. Similarly, these distinguishing characteristics impact upon the kind of pattern that is made. However, when composing differing varieties of texture and tone, designers should be prepared to make visual judgments. Logically or incrementally based changes can be a good place to start, but will not necessarily result in sufficient, meaningful change or noticeable visual difference.

Position and orientation within a layout have far less significance than density of texture and darkness of tone; key information will still be recognized as having primary importance wherever it is located, providing that it has sufficient intensity. As far as the sequencing of subsequent information is concerned, ever-decreasing tonal values will operate in tandem with Western conventions of reading from left to right and from top to bottom. Designers impose structures and style, but must always recognize Western viewers' instinctive response to return to the left edge, and to "work their way down" a layout.

TYPOGRAPHICALLY DRIVEN
HIERARCHIES

IN CONSIDERING THE ROLE OF TYPE AS A REGULATOR AND CONTROLLER OF HIERARCHIES, IT IS NECESSARY TO KEEP IN MIND THAT LETTERFORMS MAKE WORDS AND WORDS HAVE MEANINGS

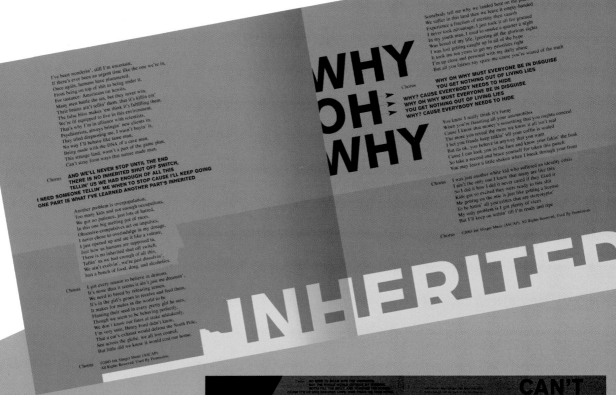

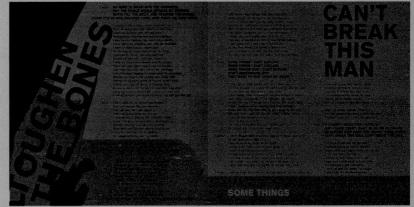

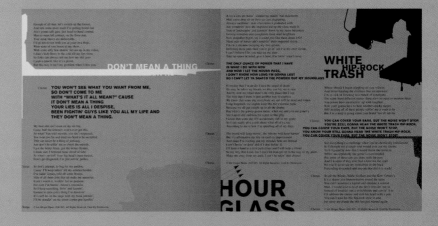

344 DESIGN, LLC
WHAT YOU THOUGHT YOU HEARD
CD PACKAGE, BORIALIS

A limited color palette and an almost entirely typographic layout typify Stefan G. Bucher's design for the CD cover of Borialis' *What You Thought You Heard*. Headings and sections of text are given prominence through bold, all cap, sans-serif letterforms, with many anchored to the bottom of the page, or running into the abstract, colored shapes that are used as illustration. Quantities of type make clever use of indented and exdented copy that repeatedly attracts the reader to where the layout changes, and encourages their continued attention through to the end.

CLIENT	DESIGN	TYPOGRAPHY	ART DIRECTION
CAPITOL RECORDS	STEFAN G. BUCHER	STEFAN G. BUCHER	MARY FAGOT
			STEFAN G. BUCHER

CLIENT	DESIGN	TYPOGRAPHY
BATTERY PARK	L. RICHARD POULIN	L. RICHARD POULIN
CITY PARKS	DOUGLAS MORRIS	DOUGLAS MORRIS
CONSERVANCY		

COPYWRITING	PHOTOGRAPHY
BATTERY PARK	VARIOUS
CITY PARKS	
CONSERVANCY	

POULIN + MORRIS INC.

BATTERY PARK CITY PARKS
CONSERVANCY 2001 PROGRAM
CALENDAR

Lilac, lime-green, and orange form an unexpected color palette for this City Parks Conservancy Calendar by Poulin + Morris. The recipient is drawn primarily to the almost electric contrast between lilac and orange, then on to the decorative display face that is used for section headings. Most smaller text—in black, and layered on top of colored backgrounds—is seen later.

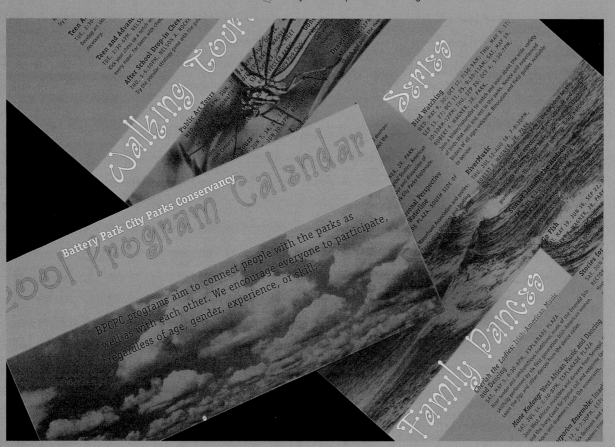

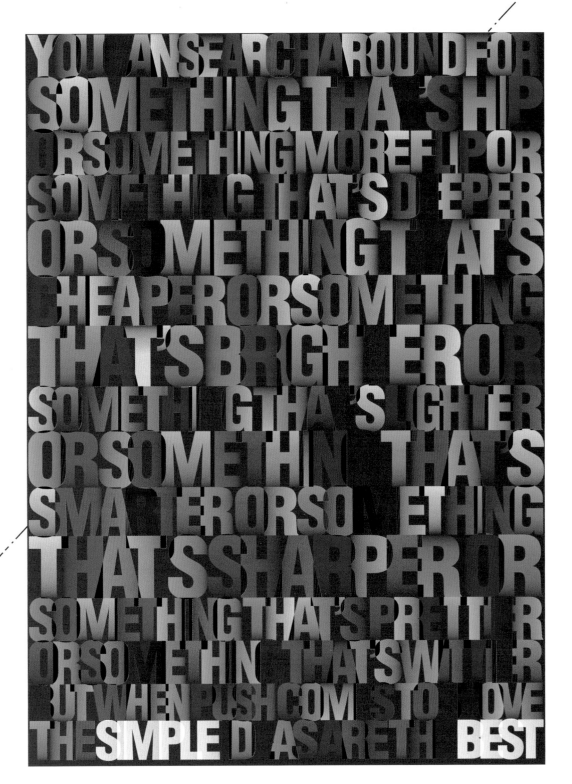

CLIENT
JOHNSON BANKS

DESIGN
MICHAEL JOHNSON

TYPOGRAPHY
MICHAEL JOHNSON

ART DIRECTION
MICHAEL JOHNSON

JOHNSON BANKS
SIMPLE POSTER

Conveying the message that simple is best was Michael Johnson's aim with this complex design. Statements built up through graduated, overlapping, colored letters of varying size form the substance of this poster. Even after trying at some length to read the complex message, the reader cannot help but be drawn to the white, "simple" and "best" along the bottom line.

CLIENT DESIGN TYPOGRAPHY
YORKSHIRE ANDREW WOOD ANDREW WOOD
FORWARD ADAM LEE TOM LEA

ART DIRECTION PHOTOGRAPHY
LEE BRADLEY TOM CHAMBERS
 MICHAEL FEATHER

BRAHM DESIGN
NEW YORKSHIRE

Creating a business magazine style with different levels of information was important to Lee Bradley in putting together his design for Yorkshire Forward. "Uppercase typography is used to highlight and draw the reader's attention" that says Lee. "Key facts are formatted within black information boxes, and large orange and white folios also draw attention" he concludes. Color is vital to this design, with silver being used as an attractive, eye-catching background for many pages.

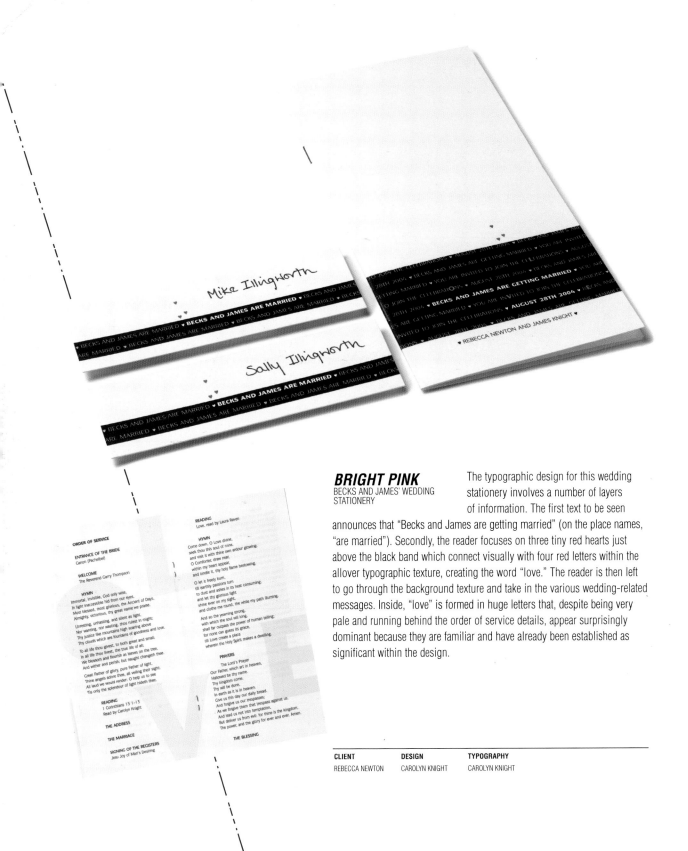

BRIGHT PINK
BECKS AND JAMES' WEDDING STATIONERY

The typographic design for this wedding stationery involves a number of layers of information. The first text to be seen announces that "Becks and James are getting married" (on the place names, "are married"). Secondly, the reader focuses on three tiny red hearts just above the black band which connect visually with four red letters within the allover typographic texture, creating the word "love." The reader is then left to go through the background texture and take in the various wedding-related messages. Inside, "love" is formed in huge letters that, despite being very pale and running behind the order of service details, appear surprisingly dominant because they are familiar and have already been established as significant within the design.

CLIENT	DESIGN	TYPOGRAPHY
REBECCA NEWTON	CAROLYN KNIGHT	CAROLYN KNIGHT

CLIENT
ISLAND RECORDS

DESIGN
JAMES KIRKHAM

ART DIRECTION
JAMES KIRKHAM

HOLLER
SPAN WEB SITE

Holler's unusual design for Island Records makes dynamic use of space and scale. "Span" changes position within the screen, but is always the most noticeable single element within the design because of its large scale, weight, and density of tone. Even when the letterforms drift partially out of sight they remain just as significant; the viewer remembers and knows what they represent. The navigation system, seen second, is also prominently displayed, using smaller, bold, black type that changes scale and color with mouse overs.

BRAHM DESIGN
CENTRES OF INDUSTRIAL
COLLABORATION BROCHURE

There was no photography available for this project. As subject matter was so diverse, Brahm had to source visually pleasing images that would function in tandem with headings. The reader is drawn first to the key words, used as headings, and then to the scientifically inspired images. Next, silver subheadings and orange introductory statements attract attention, leaving lightweight silver text as the last element to be accessed.

CLIENT
YORKSHIRE
FORWARD

DESIGN
LEE BRADLEY
MARK STARBUCK

TYPOGRAPHY
MARK STARBUCK

ART DIRECTION
LEE BRADLEY

Particle Science & Engineering

Optimise

Research is delivering rapid improvements in our understanding of the properties of particles. The ability to measure and characterise ever smaller particles is transforming our ability to make and process materials.

Materials Analysis & Research Services

Materials research has produced astonishing advances in recent years with new products and processes creating exciting opportunities for forward-thinking businesses.

Breakthrough

Biomaterials & Tissue Engineering

Connect

Designing, developing and commercialising the Biomaterials & Tissue Engineering products of the future is an exciting challenge.

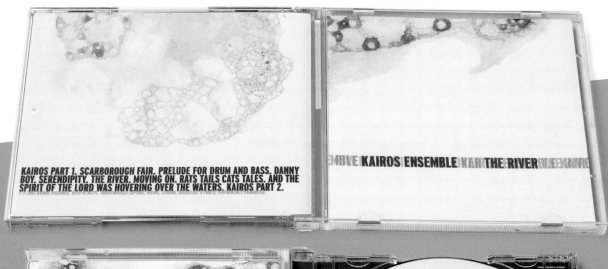

KAIROS PART 1. SCARBOROUGH FAIR. PRELUDE FOR DRUM AND BASS. DANNY BOY. SERENDIPITY. THE RIVER. MOVING ON. RATS TAILS CATS TALES. AND THE SPIRIT OF THE LORD WAS HOVERING OVER THE WATERS. KAIROS PART 2.

KAIROS PART 1 1:36 KAIROS ENSEMBLE
SCARBOROUGH FAIR 4:13 TRAD. ARR. DAN FOSTER
PRELUDE FOR DRUM AND BASS 3:37 PETER JAMES
DANNY BOY 4:38 TRAD. ARR. PETER JAMES
SERENDIPITY 4:33 RICHARD FOX
THE RIVER 10:58 PETER JAMES
MOVING ON 3:07 DAN FOSTER
RATS TAILS CATS TALES 3:21 PETER JAMES
AND THE SPIRIT OF THE LORD WAS HOVERING OVER THE WATERS 7:23 KAIROS ENSEMBLE
KAIROS PART 2 8:01 KAIROS ENSEMBLE

CLIENT	DESIGN	TYPOGRAPHY
KAIROS ENSEMBLE	GARY MACILWAINE	GARY MACILWAINE

ART DIRECTION	ILLUSTRATION
GARY MACILWAINE	RACHEL COLLINSON

SPARKS PARTNERSHIP
THE RIVER CD PACKAGING

A prominent, dense line of layered type runs through this design for Kairos Ensemble, and as a result of the density of color and tone it is definitely the first element to be seen. "The idea was to communicate the motion and effect of water, while retaining readability and correct reading order," says Rachel Collinson of Sparks Partnership. "The text has been layered to create a kind of flow, and color is used to pull out the title from the main 'river'," she continues.

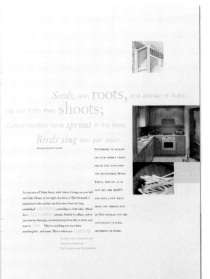

CLIENT	DESIGN	TYPOGRAPHY
WIMPEY EAST	JESSICA GLASER	JESSICA GLASER
MIDLANDS	CAROLYN KNIGHT	CAROLYN KNIGHT

COPYWRITING	ART DIRECTION
CAROLYN KNIGHT	JESSICA GLASER
	CAROLYN KNIGHT

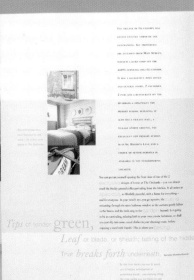

BRIGHT PINK
THE ORCHARDS, BROCHURE

Within the pages of this brochure for Wimpey housebuilders, a distinct patchwork of many deep-colored images exists, but it is the typographic patchwork that we will focus on and discuss within this section.

A mix of type sizes, weights, and colors have been brought together, creating a palette of typographic treatments that not only complement each other, but also set up recognizable styles for different levels of information. Density of tone—controlled by type size, leading, intercharacter space, and color—plays a large role in directing the order in which this information is accessed. Readers are likely to be drawn to the largest type first—the lowercase words form verses of Christina Rossetti's poetry. Smaller, black text is then accessed, with bold, blue, all cap, widely leaded copy being seen next.

POULIN + MORRIS INC.
SUSPICION BOOK JACKET

Large, bright white typography, extending vertically down the cover, is seen first on this jacket for *Suspicion*, designed by Poulin + Morris. This prioritizing is a direct result of the titling and author detail contrasting dramatically with the red-and-black halftone photography that completes this cover design. The red, as well as being bright, has a fairly dark tone which throws out the white type particularly strikingly.

CLIENT	DESIGN
NORTON	L. RICHARD POULIN

TYPOGRAPHY	PHOTOGRAPHY
L. RICHARD POULIN	ANN SPINDLER
	GRAPHIS PHOTO

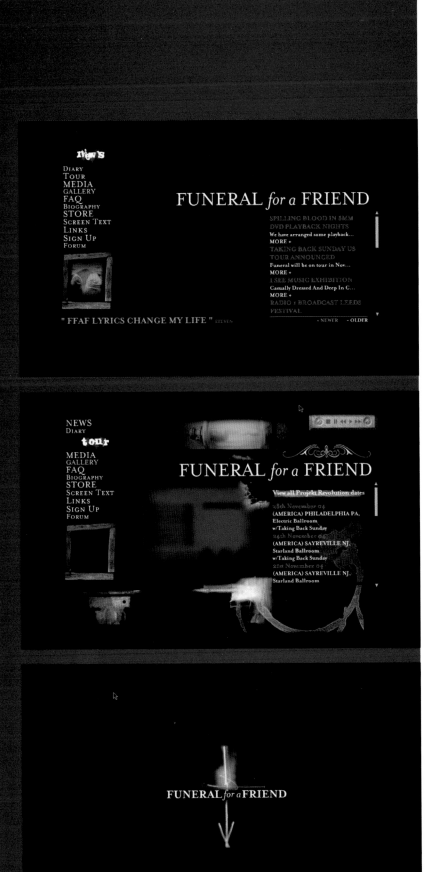

CLIENT	DESIGN
WARNER MUSIC	WILL PYNE

TYPOGRAPHY	ART DIRECTION
WILL PYNE	WILL PYNE

HOLLER
FUNERAL FOR A FRIEND WEB SITE

This Web site opens with the band's name, Funeral for a Friend, dramatically interpreted in white "haloed" type on a black background, using a typeface reminiscent of those on sympathy cards. The impact is so powerful, and the appearance so distinctive that, despite the introduction of full-color imagery on subsequent pages, the viewer is persistently drawn to and through the white-on-black text, whether this be heading, subheading, or body copy.

CLIENT	DESIGN
SLM	MIRCO ILIC

ART DIRECTION	PHOTOGRAPHY
MIRCO ILIC	LUKA MJEDA

MIRKO ILIC CORP.
B&W ZAGREB

Strong, white, sans-serif, all cap letters are the most noticeable elements in this design, both when it is folded to form a dust jacket for Luka Mjeda's book, and when it is opened out to create a poster. This is particularly because of their scale, clarity, and contrast with the monochrome sections of buildings behind them, but also because, strikingly, they bleed off two edges of the front cover of the book, and run vertically as well as horizontally in the poster, with some words actually upside down.

CLIENT	DESIGN	TYPOGRAPHY
SELF-PROMOTIONAL PROJECT	MATEEN KHAN	MATEEN KHAN

ILLUSTRATION	PHOTOGRAPHY
MATEEN KHAN	MATEEN KHAN

MATEEN KHAN DESIGN
1984, MULTIMEDIA PIECE

The designer's intention in this multimedia piece is to create an interactive environment that reflects his personal interpretation of George Orwell's novel *1984*. Haunting words and phrases attract the viewer initially, as they are the clearest elements within each page, and because they stir chilling emotions. It is human nature to have a fascination with the macabre, and the viewer readily allows the words to set the scene. Cut-up type, dark gritty images, and carefully selected colors then build up the atmosphere, with smaller text, and less legible type drip feeding further sinister narrative.

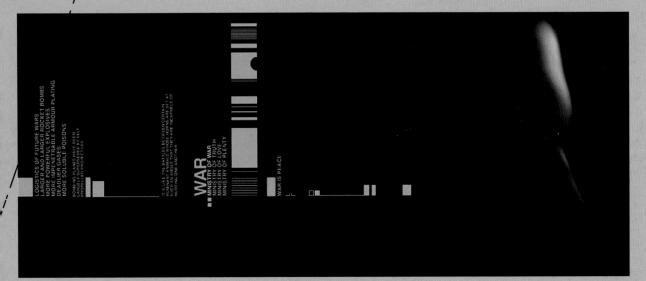

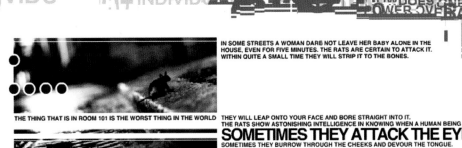

344 DESIGN, LLC
AMERICAN PHOTOGRAPHY 17,
BOOK DESIGN

"Seduced and Enlightened" is the title of the opening spread in Stefan G. Bucher's design for *American Photography 17*. This design proves that titles do not have to sit at the top of the page to be read first; neither do they have to be shown in the darkest, or deepest color. Surprisingly, on these pages, the reader is drawn first to the large, white, sans-serif, all cap heading, which is reversed through a light, flesh-colored background. They are then guided on to view the lighter texture and tone of copy printed in black.

CLIENT	DESIGN
MARK	STEFAN G. BUCHER
HEFLIN/AMILUS INC.	

TYPOGRAPHY	ART DIRECTION
STEFAN G. BUCHER	STEFAN G. BUCHER

FISHTEN
WABI SABI CATALOG

This unusual format was devised by Fishten for the catalog of an exhibition concerning contemporary Japanese ceramics. Entitled Wabi Sabi, the catalog visually sets the scene for this hybrid North American/Japanese exhibition. All imagery is restricted to the small, outer, wraparound sections, with the rest of the catalog devoted to text and a thoughtful typographic interpretation of contemporary Japanese arts culture. Typographic treatments ensure that the type is striking. These include large paragraph indents, line breaks in the middle of words, and paragraph orientations at 90˚ to each other, all situated in generous space. Printed in single color, each page uses a weighty pink bar that acts as an anchor, drawing both text and the reader's attention toward the bottom of each spread.

CLIENT	DESIGN	TYPOGRAPHY
MOOSE JAW MUSEUM & ART GALLERY	GILES WOODWARD KELLY HARTMAN	GILES WOODWARD KELLY HARTMAN

COPYWRITING	ART DIRECTION	PHOTOGRAPHY
HEATHER SMITH	GILES WOODWARD KELLY HARTMAN	STUART MUELLER

TWO

IMAGE DRIVEN

This section examines how imagery controls hierarchy in a layout. Just as the previous section does not deal exclusively with type, so the content in this part does not talk about the use of imagery alone. Unless a design excludes type altogether, text will contribute to the hierarchical structure, as all elements within a layout are viewed in relation to each other.

The most significant aspect of sequencing visual perceptions through imagery is the subject matter of the images. It is interesting to recognize the magnetic power of the human (and to some degree animal) form. In many of our day-to-day communication processes we look at whoever is speaking to us, and body language, especially facial expressions and hand gestures, are integral to our comprehension. Consequently, the inclusion of a picture showing a person, or in fact any part of the human body, provokes an involuntary focus of attention. Faces, eyes, mouths, and hands all draw the viewer's attention.

Visual themes that stir emotions and aspirations are particularly inclined to attract attention. Violent, sentimental, or shocking topics tend to be more alluring, and images of kittens or babies, famine or war, are always likely to secure visual priority. It is also natural to dream of improving, changing, or updating ourselves, our homes, and our lives, and images that depict such desires can be amazingly seductive, regardless of the visual treatment.

The cropping of imagery has a fascinating impact upon ordering the content of a layout. Newspapers very often use the same photograph of an event, but crop it differently. The tabloids often seek immediate attention, with images that exclude the wider environment and focus on the emotional closeness of a moment. Broadsheets tend to allow the viewer more time to take in the whole picture, and maybe create a sensitive headline that is perceived first, to set the scene. Cropping can also create very unusual and unexpected image content that draws attention because the reader is curious or mystified. Synergic meaning can be particularly intense and inviting, as when a number of images are cropped and juxtapositioned in a surprising manner.

Many of the same principles that affect typographic hierarchies are pertinent to the visual sequencing of imagery. Darker tonal values and dynamic textural patterning will dominate within a layout whether created by type or image, and spatial distribution, together with changes of scale, can be used in just the same way to draw the reader's eye. Pictures, however, constitute a universal language that is accessible to all, for the most part transcending nationality and, to some degree, age.

Pictures can also convey a huge amount of information far more speedily than the numerous words that would be needed in their place. Therefore, as it is human nature to assimilate the most easily accessed information first, the dominant feature is likely to be imagery. If imagery is to be read after type, all aspects of tone, texture, color, scale, composition, and, of course, content must be carefully balanced in order to reduce its level of prominence.

Graphic elements, such as geometric shapes, background tints, and patterns, all come under the image banner, and play various roles in the hierarchical chain. Daniel Bastian from Form Fuenf Bremen, has produced a brochure for Scharf.Rechtsanwälte that uses dots as attention grabbers and persistent visual markers to lead the reader through the pages. Even when the dots become fainter they rank high in the order of perception, as the reader is geared to seeing them as an informational system.

Background tints and patterns are rarely overtly acknowledged as being viewed first, but intriguingly, they have the ability to set the scene, and can give a masculine, feminine, or cultural bias to a design; a floral texture will be perceived as feminine, checkerboard squares are more likely to be viewed as masculine, and batik will immediately add cultural connotations. In Lauren Schulz's design for *Surface* magazine, cultural patterns play an important role. A contemporary take on traditional Japanese prints makes the article's subject immediately clear to viewers. Whether consciously or unconsciously, readers will absorb this information before taking in other elements in more detail, and it will influence their perception and interpretation of everything else.

The metonymic and metaphorical use of imagery can add to its power. In many respects, it is the simplicity and immediacy of visual elements that enable them to be seen and understood comparatively instantly. Metonymy uses one person or object to represent a far greater whole. Visual metaphor points out resemblance by using substitution in a very poignant manner; for example, if a national identity in the form of a flag becomes the design featured upon a doormat, the intended perception of that country is very clear.

The following pages examine exercises and examples of work that involve some of the design decisions to be made in order to create different levels of hierarchy with image. As with the designs featured in the first section, they serve merely as models that demonstrate some of the numerous approaches available within both print and screen contexts.

CLIENT	DESIGN	COPYWRITING
SURFACE MAGAZINE	LAUREN SCHULZ	KATIE JACQUARDE

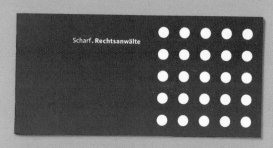

Scharf. Rechtsanwälte

CLIENT	TYPOGRAPHY	COPYWRITING
SCHARF.RECHTSANWÄLTE	DANIEL BASTIAN	SCHARF.RECHTSANWÄLTE

ART DIRECTION	PHOTOGRAPHY
DANIEL BASTIAN	KAI MICHALAK

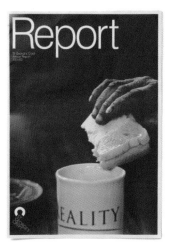

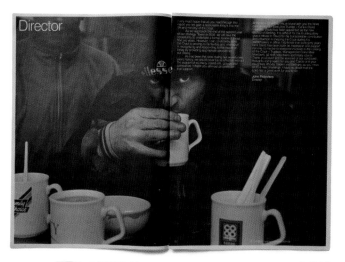

CLIENT	DESIGN	TYPOGRAPHY
ST GEORGE'S	LEE BRADLEY	LEE BRADLEY
CRYPT	MARK HOWE	
	MARK STARBUCK	

	ART DIRECTION	PHOTOGRAPHY
	LEE BRADLEY	JOHN ANGERSON

BRAHM DESIGN
REALITY, ANNUAL REPORT &
ENTERTAINING ANGELS BOOK DESIGN

Shown on these pages are Brahm Design's solutions to an annual report, and a book about St George's Crypt. Both pieces make dramatic use of impactive black-and-white photography, which is always seen first. "The documents have simple typography and layout that complement the powerful photography. Most spreads have a main heading, text content, and image," says Lee Bradley, Brahm Design team head.

Entertaining Angels is designed in such a way that readers can access information from any page, without the need to read the entire book from start to finish. Images that are dramatically cropped dominate the pages; all are carefully placed to create the most impact.

Reportage Photography
John Angerson

32

Introduction

Homelessness is an age old problem. For those who have nowhere to go the situation is no less harsh in the 21st century than it was in the 1930s. For most of society it is something which happens to someone else, something that must have been 'their' fault, something easier to ignore and turn away from than to embrace. *Entertaining Angels* tells the stories of hundreds of people touched by homelessness, and the spirit which shines through their encounters with each other and the rest of the world. What they all have in common is the warmth and friendship offered at St George's Crypt – for some people a lifetime.

The memories are evocative; of times past, but also of situations still happening in the city of Leeds today. From an 81 year old woman who waited for the scraps left from breakfast and hoped for occasional presents of clean clothes, to the man who collected old newspapers from bins and then handed them out like a paper delivery boy for everyone to read.

These are also the stories of the men and women who drink themselves into oblivion, of those whose shoes fit so badly that their toe nails grow underneath their feet, and of the scores of helpers from all walks of life whose care and dedication have helped to make lives a little better.

Collectively their memories and the photographs which go with them capture the history of the Crypt over more than 70 years. We are proud to have been involved in this project.

Clare Morrow, Controller of Programmes, Yorkshire Television

St George's Crypt
Entertaining Angels
Editor Ian Clayton
Photographs by John Angerson

CLIENT	DESIGN	TYPOGRAPHY
ST GEORGE'S CRYPT	LEE BRADLEY	LEE BRADLEY

COPYWRITING	ART DIRECTION	PHOTOGRAPHY
IAN CLAYTON	LEE BRADLEY	JOHN ANGERSON

CLIENT	DESIGN	TYPOGRAPHY
THE WIRE	KJELL EKHORN	KJELL EKHORN
MAGAZINE	JON FORSS	JON FORSS

	ART DIRECTION	PHOTOGRAPHY
	KJELL EKHORN	JAKE WALTERS
	JON FORSS	

NON-FORMAT
ADRIATIC BLUES, MAGAZINE SPREAD

The dominant portrait instantly catches the reader's attention in this article for *The Wire* magazine. It is not only the scale or cropping of the image that causes this photograph to be so arresting, but the fact that Christian Fennesz is looking directly into the eye of the viewer. Decorative, lightweight, outline letters are the next element to be seen, and these make up an unexpected heading for the article.

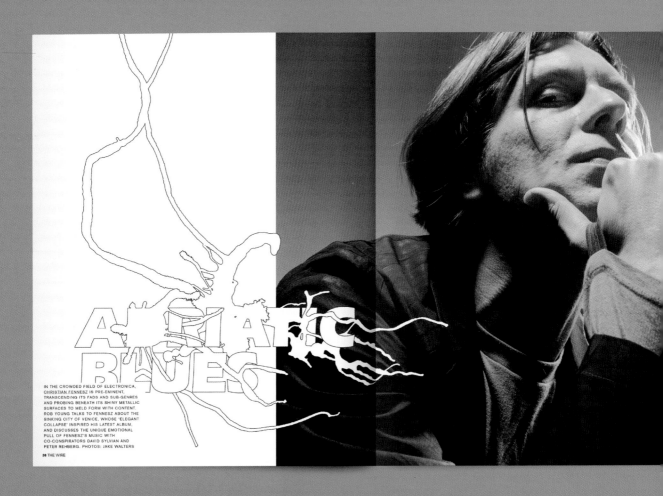

IN THE CROWDED FIELD OF ELECTRONICA, CHRISTIAN FENNESZ IS PRE-EMINENT, TRANSCENDING ITS FADS AND SUB-GENRES AND PROBING BENEATH ITS SHINY METALLIC SURFACES TO MELD FORM WITH CONTENT. ROB YOUNG TALKS TO FENNESZ ABOUT THE SINKING CITY OF VENICE, WHOSE 'ELEGANT COLLAPSE' INSPIRED HIS LATEST ALBUM, AND DISCUSSES THE UNIQUE EMOTIONAL PULL OF FENNESZ'S MUSIC WITH CO-CONSPIRATORS DAVID SYLVIAN AND PETER REHBERG. PHOTOS: JAKE WALTERS

36 THE WIRE

CLIENT	DESIGN
CRAFTS COUNCIL	IAN PIERCE

ART DIRECTION	PHOTOGRAPHY
ALAN DYE	MARTIN MORRELL
BEN STOTT	
NICK FINNEY	

NB: STUDIO
JERWOOD APPLIED ARTS PRIZE
2003: GLASS

NB: Studio have created an abstract effect by using fluted glass for this image-driven piece designed to publicize the Jerwood Applied Arts Prize, which was awarded for glass in 2003. The viewer is instantly intrigued by the obscured view offered by this decorative glass. Ian Pierce has used enlarged sections of the image to create equally captivating cover and postcard imagery. Headings and titles are seen after the image, despite being created with a bold, stencil-effect, sans-serif typeface. Supporting copy is seen last, but is integrated through use of turquoise tones drawn from the color palette of abstract imagery.

SCANDINAVIAN DESIGN GROUP
PRICEWATERHOUSECOOPERS
IMAGE BROCHURE

Within the pages of this PriceWaterHouseCoopers image brochure, the viewer is drawn into spread after spread of full-color image. Each shot bleeds off four edges and all type is overlaid. Because of the scale and quality of the photography, viewers will seek to look through the panels of white copy, deep into the scenes of the company's life.

CLIENT
PRICEWATERHOUSE
-COOPERS

DESIGN
JESPER VON
WIEDING

MUGGIE RAMADANI

COPYWRITING
SIGNE DUUS

ART DIRECTION
JESPER VON
WIEDING

MUGGIE RAMADANI

PHOTOGRAPHY
SIMON LADEFOGED

CLIENT	DESIGN	TYPOGRAPHY
ZUMTOBEL AG	MATTHAIS ERNSTBERGER	MATTHAIS ERNSTBERGER

COPYWRITING	ART DIRECTION	PHOTOGRAPHY
OTTO RIEWOLDT	STEFAN SAGMEISTER	BELLA BORSODI

SAGMEISTER INC.
ZUMTOBEL ANNUAL REPORT

In this annual report for Zumtobel AG, Sagmeister Inc. chose to photograph and feature a heat-molded relief sculpture under different lighting conditions, "illustrating the incredible power of changing light," says Stefan Sagmeister. The effect is to give the image varying characteristics, and in particular, differing prominence. Essentially, the hierarchical arrangement of elements within a layout is to apportion changing emphasis, and the stronger the tonal and textural values, the more attraction is achieved. Viewing the silver-effect shot, strong contrasting shadows have been created to make the image eye-catching and dominant. This then establishes a visual link with the small, bold heading on the left edge of the opposite page, taking the viewer to the beginning of the text. Analyzing the sequencing of information within this spread, it is easy to recognize the path from photograph to bold heading, to decorative rule complete with floral icon, and finally to the main body of blue-gray text.

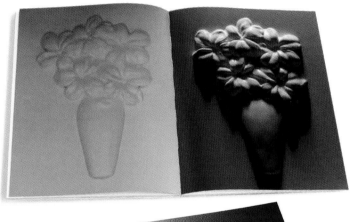

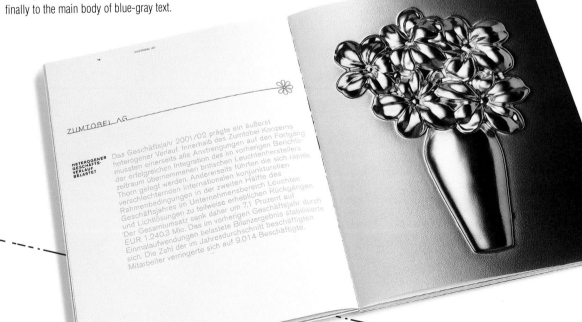

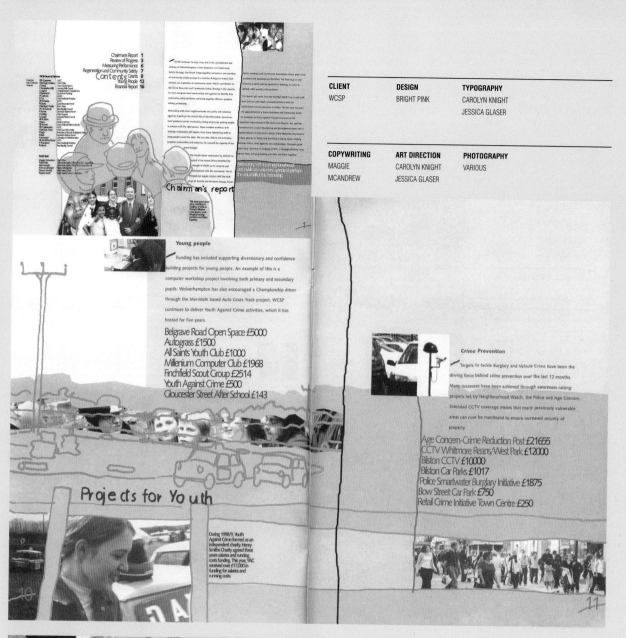

CLIENT	DESIGN	TYPOGRAPHY
WCSP	BRIGHT PINK	CAROLYN KNIGHT
		JESSICA GLASER

COPYWRITING	ART DIRECTION	PHOTOGRAPHY
MAGGIE	CAROLYN KNIGHT	VARIOUS
MCANDREW	JESSICA GLASER	

BRIGHT PINK
WCSP ANNUAL REVIEW

Dry information is enlivened in these spreads from WCSP's Annual Review through an animated interplay of illustration, photography, type, and color. The linear illustration style is used for headings, and combined with unusually shaped photographs to create an overall image-driven approach. Much of the hierarchy of these pages is established by the changes in scale and use of media, resulting in engaging, characterful variety and intriguing depth.

The two-color blend of imagery produces a textural and tonal mix that embraces the larger type, ensuring that it too, initially, is viewed as image within the first and second levels of this piece.

CLIENT	DESIGN	PHOTOGRAPHY
SURFACE MAGAZINE	RICHARD SMITH	BLINKK

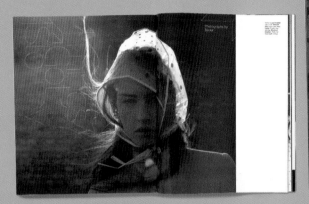

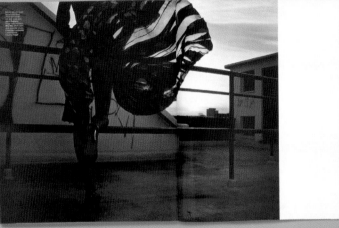

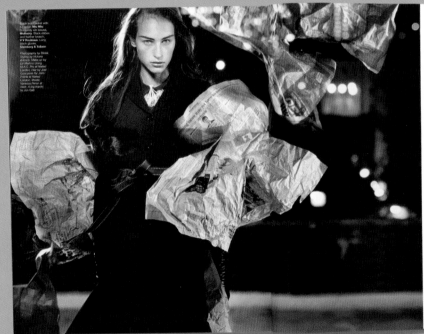

EXQUISITE CORPORATION
THINGS GOT STORMY
FASHION EDITORIAL

Dark, moody images extend across the spreads of *Surface* magazine's "Things Got Stormy," with each right-hand page containing a broad white panel that accommodates and separates caption detailing. However, there is no doubt that viewers will be drawn to Blinkk's atmospheric photography first because of its dark tones and consequent visual power. In addition, the titling for this fashion editorial, although large in size, is hairline in weight, and this allows the focus to be on the image behind it.

JOHNSON BANKS
V&A SUMMER POSTER

johnson banks' promotional poster for the permanent collection of the V&A simply features an evocative black-and-white photograph from the museum's classical sculpture collection. This shot commands attention, drawing the reader through the cleverly crafted heading to focus on the smooth lines of the figure.

CLIENT	DESIGN	TYPOGRAPHY
VICTORIA AND ALBERT MUSEUM (V&A)	MICHAEL JOHNSON LUKE GIFFORD	MICHAEL JOHNSON LUKE GIFFORD

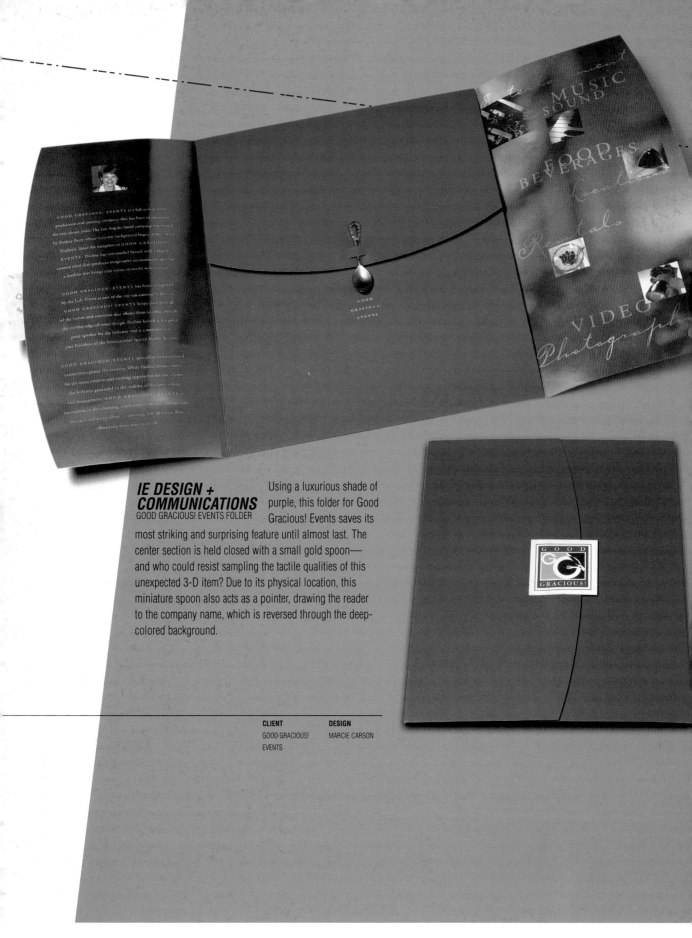

IE DESIGN + COMMUNICATIONS
GOOD GRACIOUS! EVENTS FOLDER

Using a luxurious shade of purple, this folder for Good Gracious! Events saves its most striking and surprising feature until almost last. The center section is held closed with a small gold spoon—and who could resist sampling the tactile qualities of this unexpected 3-D item? Due to its physical location, this miniature spoon also acts as a pointer, drawing the reader to the company name, which is reversed through the deep-colored background.

CLIENT
GOOD GRACIOUS!
EVENTS

DESIGN
MARCIE CARSON

Introducing one of the most respected names in international textiles. A company that adds value to your business by producing high quality products. Welcome to the world of Bulmer & Lumb.

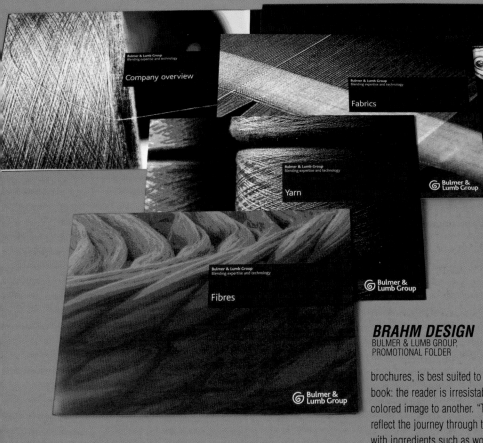

BRAHM DESIGN
BULMER & LUMB GROUP,
PROMOTIONAL FOLDER

There is no doubt that this folder, containing a number of landscape-format brochures, is best suited to the image-driven section of this book: the reader is irresistably drawn from one brightly colored image to another. "The first spread uses images to reflect the journey through the textiles business, starting off with ingredients such as wool and finishing with the end product—cloth," says Lee Bradley of Brahm Design. "Color needs to come across strongly," he continues, "as dyeing is a core activity for Bulmer & Lumb." Dynamic contrasts of scale within the imagery contribute to the vitality of the spreads, and also affect the hierarchical status.

CLIENT	DESIGN	TYPOGRAPHY
BULMER & LUMB GROUP	LEE BRADLEY ZOE TYLER	LEE BRADLEY ZOE TYLER

COPYWRITING	ART DIRECTION	PHOTOGRAPHY
BILL LYNE	LEE BRADLEY	JOHN HUTCHINSON

CLIENT	DESIGN	TYPOGRAPHY	COPYWRITING	ILLUSTRATION
RECHORD	RACHEL COLLINSON	IDENTIKAL	STEFAN CARTWRIGHT	RACHEL COLLINSON

RECHORD
RECHORD WEB SITE INTERFACE

Hierarchies within the pages of Web sites may not be finite as elements are likely to change with, for example, mouse overs, as well as through animation. Rachel Collinson, of rechord, has chosen to add to this "infinity" by offering the viewer some control over the dominance of areas, giving them the opportunity to change colors with the mood-mixer buttons, and even to turn off the eight squares that constitute the interface if they appear too powerful. As a consequence, the visual dynamic moves from one area to another, and can be governed by the open door, the interface, or the interactive zone on the left. These screenshots show some of the alternatives available, and demonstrate the changes in emphasis.

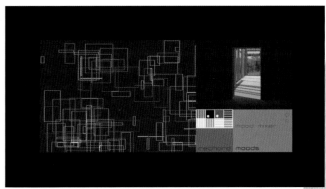

KINETIC
TIME OF REBIRTH
CD PACKAGING

Tonal values generally play a strong part in governing the hierarchy of a composition—the darker the tone, the more it attracts attention. However, on the pages of the booklet that comes with this CD, it is interesting to note that certain experiential recollections influence the order of reading and override the tonal principles. Hand-drawn, handwritten elements make a more direct and personal connection, and crossed-out text, together with torn-out pages, dominate by creating a certain discomfort in the viewer. The piece demonstrates one of the most intriguing aspects of ordering information—the need to be aware of an audience's knowledge and experience, which in this case probably taps into memories of school.

CLIENT	DESIGN	TYPOGRAPHY	COPYWRITING
THE OBSERVATORY	PANN LIM	PANN LIM	LESLIE LOW
	LENG SOH	LENG SOH	

ART DIRECTION	PHOTOGRAPHY	ILLUSTRATION
PANN LIM	PANN LIM	PANN LIM
LENG SOH	LENG SOH	LENG SOH
ROY POH		

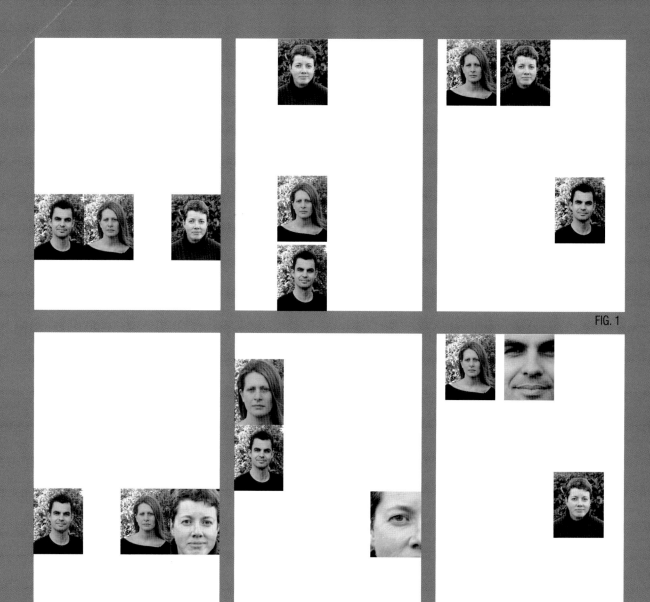

FIG. 1

FIG. 2

EX05

CROPPING AND CHANGE OF SCALE

Subject matter does influence the order of perception, however, the way in which designers use imagery can increase hierarchical control, whatever the content. This exercise seeks to isolate some of the basic principles of layout that can affect the order in which images are seen, such as spatial distribution, groupings, and changes of scale. Essentially simple alternatives, in many cases with minimal changes, are able to impact upon hierarchy.

Given a constant A5 (8¼ × 5¾in/210 × 148mm) format, arrange three similar, squared-up head-and-shoulders portraits within the space, and follow a three-stage sequence of changing parameters. All images remain in black-and-white to avoid the influence of color. Cut-outs are not an option.

1. Keep all three image boxes portrait, 1½ × 2¼in (40 × 52mm), and the size and cropping of the portraits inside the boxes the same as each other. The positioning of the three elements is the only area for manipulation.

2. As above, but this time you can change the scale and cropping of the portraits inside the boxes. Repeat compositions from part 1 to observe the differences in hierarchy.

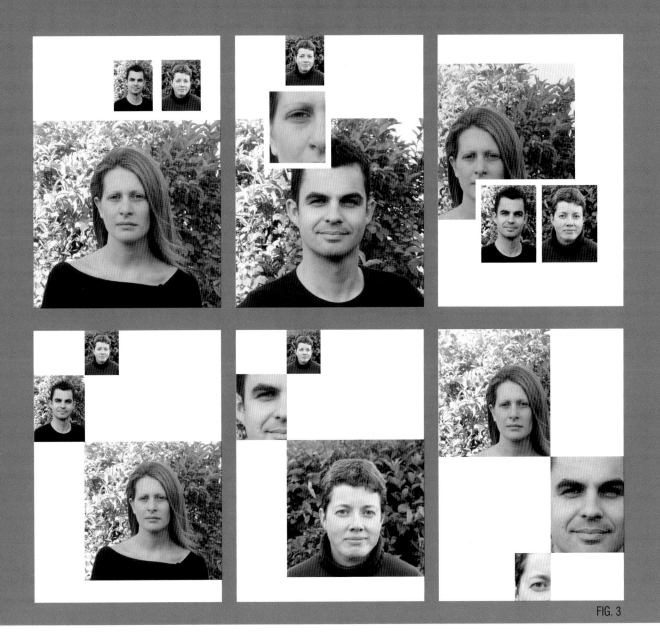

FIG. 3

3. You can change the size of the image boxes and the scale and cropping of the images. In some instances the largest image will dominate, but you will gain most from this exercise if you use space constructively, for example, by aiming to make the smallest image the most prominent.

In Fig. 1, distancing one image from the other two appears to draw attention to it. However, positioning images approximately two-thirds of the way down a composition also seems to provide a comfortable eye level for viewers, and the top image of the two sitting close to each other will be viewed first of all.

Fig. 2 confirms that positioning is important, but suggests that larger images, particularly when closely or unusually cropped, will generally dominate more distant shots.

Fig. 3 confirms that there are infinite alternatives; the few shown here demonstrate that scaling and positioning follow the same pattern as in figs.1 and 2, but that it is very difficult to reduce the impact of large, framed pictures. Overlapping images, physically bringing them to the front, appears to be a successful device, although it is most effective when white space separates elements.

who are you?

CLIENT	DESIGN	TYPOGRAPHY
PHOTO '98 YEAR OF PHOTOGRAPHY AND THE ELECTRONIC IMAGE	DOM RABAN	DOM RABAN

ART DIRECTION	PHOTOGRAPHY
DOM RABAN	PAULA SUMMERLEY

EG.G
BODY:INK PUBLICATION

A vibrant interplay of text and image runs through both sides of this publication, which explores the relationships of body, text, and image. Because the imagery is predominantly of the human form, it is very strong and dominant. Exciting contrasts of scale, dynamic angles, and bright colors are particularly alluring, but it is interesting to note that even the monochrome, squared-up strips of shots draw the viewer's eye, because they are of people.

GR/DD GRAPHIC RESEARCH DESIGN DEVELOPMENT
MACCORMAC JAMIESON PRICHARD (MJP ARCHITECTS) WEB SITE

Making dramatic and impactive use of deep-blue and high-contrast imagery, the concept behind this Web site is based upon layers of frosted glass, a material that MJP frequently use in their work. "This site contains a high amount of text- and image-based information," says James Bowden of GR/DD. "The aim of the site is to deliver information in a clear and concise way, enabling the user to move fluidly and jump from any info layer back to the main menu," he concludes.

CLIENT	DESIGN	TYPOGRAPHY	COPYWRITING
MJP ARCHITECTS	SIMON YUEN	JAMES BOWDEN	MJP ARCHITECTS
	JULIEN		
	DEPREDURAND		

ART DIRECTION	PHOTOGRAPHY	ILLUSTRATION
JAMES BOWDEN	MJP ARCHITECTS	JAMES BOWDEN

CLIENT	ART DIRECTION
MOMENTUM PICTURES	ALAN DYE
	BEN STOTT
	NICK FINNEY

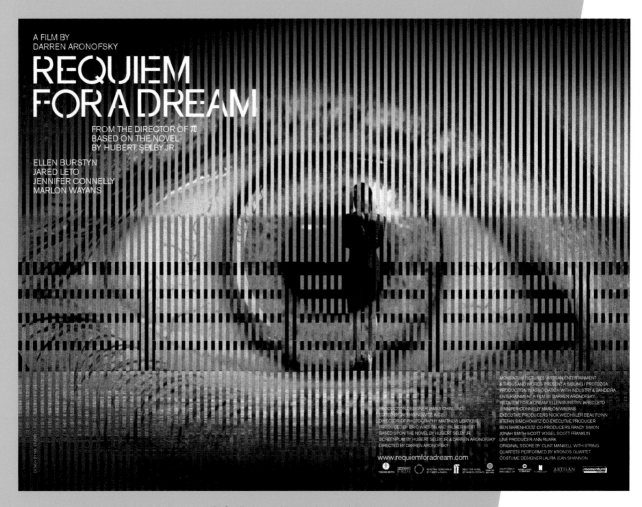

NB: STUDIO
REQUIEM FOR A DREAM
FILM POSTER

NB: Studio have taken two images from the film *Requiem for a Dream* and spliced them together, interweaving them with a third typographic element. The resulting poster has a slightly disorientating effect, with both images being visible at the same time, in the same space. Although the viewer is aware of both shots, the close-up of the eye, due to its vast scale and centered position, is most dominant, appearing almost as the center of attention for the figure looking into the distance in the second image.

CLIENT	DESIGN	PHOTOGRAPHY
WAITROSE	ISABEL ABBOTT	VARIOUS

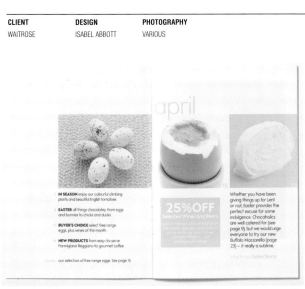

WAITROSE
WAITROSE SELECTIONS, APRIL

In the April edition of *Waitrose Selections*, mouthwatering enticement is at work—stunning food photography and styling irresistibly attracts the reader. From the very outset, Isabel Abbott has established a consistent spring color theme of yellow and green; even for the contents page products are shot to reflect this. Items are also shown in enticing contrasting scales, with small things, such as boiled eggs, appearing in enlarged, close-up glory, while brightly colored Easter eggs are featured grouped, at a smaller size.

Pages 6 and 7 of the magazine develop the color theme, featuring green in a deeper tone in a striking photograph of tomatoes. This stunning image is guaranteed to draw the reader's eye away from the heading and the associated explanatory text.

CLIENT	DESIGN	TYPOGRAPHY
DCM-DOLL CAPITAL MANAGEMENT	EARL GEE	EARL GEE

	COPYWRITING	ART DIRECTION
	EARL GEE	EARL GEE

GEE + CHUNG DESIGN
DCM HOLIDAY COASTERS

In contrast with the traditional venture capital holiday card, this set of coasters provides a functional, and more memorable way of sending season's greetings and, at the same time, promoting the company through its initials—DCM. "Our solution layered the firm's initials with line drawings of a snowman, a reindeer, an angel, and a dove, expressing the company's core values of relationships, experience, performance, and opportunity," says Earl Gee. In many respects the bold, bright red letterforms dominate, but because they so cleverly relate to the shapes of the holiday themes, it is likely that the latter are seen first. Icy blue bands containing white snow crystals run behind the images, and these also play a part in making the seasonal subject matter the focus of attention.

CLIENT
SURFACE
MAGAZINE

DESIGN
RICHARD SMITH

COPYWRITING
PAUL YOUNG

ART DIRECTION
RILEY
JOHNDONNELL

ILLUSTRATION
NEIL SHRUBB

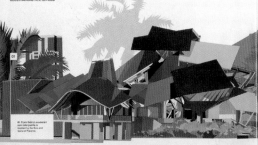

Petals to the metal

ILLUSTRATIONS NEIL SHRUBB

Is Frank Gehry an artistic wonder or just the Bilbao bully? Panama is about to find out
BY PAUL YOUNG

architecture

EXQUISITE CORPORATION
PETALS TO THE METAL
MAGAZINE FEATURE

Neil Shrubb's colorful illustration of Frank Gehry's new Panamanian building dominates the pages of "Petals to the Metal." Brightly colored roofing structures, originally inspired by the flora and fauna of Panama, attract attention while the surrounding white space accommodates a large heading, which is seen second. The article itself, also sitting upon panels of white space, makes up the third layer of this "sandwich."

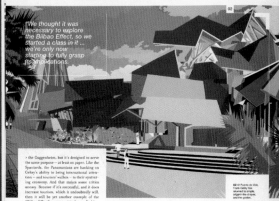

"We thought it was necessary to explore the Bilbao Effect, so we started a class in it ... we're only now starting to fully grasp its implications."

EXQUISITE CORPORATION

SEEING THINGS, MAGAZINE COVER AND ADVERTISING FEATURE

In the introduction to this section we suggested that, above all else, viewers are drawn to facial features as the main focus of their attention. This cover and article from *Surface* magazine issue 47 provide excellent examples of how difficult it is for viewers to resist meeting a photographic gaze, and demonstrate why so many magazine covers include images of faces. Torkil Gudnason's skillfully directed and tightly cropped images, despite avoiding direct eye contact with the model, are still able to expertly direct and hold the viewer's interest.

CLIENT	DESIGN
SURFACE	LAUREN SCHULZ
MAGAZINE	

ART DIRECTION	PHOTOGRAPHY
RILEY	TORKIL GUDNASON
JOHNDONNELL	

Black rhinestone studded sun-
glasses, Valentino. Sofas,
MDF Italia

Opposite Silver lower-rimmed
sunglasses, **MaxMara**

Visions of the future, Italian style.
Machine-age engineering meets
chic proportions and clean lines
to create designs guaranteed
not to reflect poorly on you
IMAGES BY TORKIL GUDNASON

STYLE

Seeing
Things

Gunmetal single lens sunglass-
es, D&G. Royal armchair, IPE
Cavalli

Opposite Smoked lens sun-
glasses, Tom Ford for Gucci.
Sofa, **Cassina**

CLIENT	DESIGN	TYPOGRAPHY	COPYWRITING
CENTRAL SAINT MARTINS COLLEGE OF ART AND DESIGN	SIMON YUEN JULIEN DEPREDURAND	JAMES BOWDEN	CENTRAL SAINT MARTINS COLLEGE OF ART AND DESIGN

ART DIRECTION	PHOTOGRAPHY	ILLUSTRATION
JAMES BOWDEN	CENTRAL SAINT MARTINS COLLEGE OF ART AND DESIGN	JAMES BOWDEN

GR/DD GRAPHIC RESEARCH DESIGN DEVELOPMENT
CENTRAL SAINT MARTINS ANNUAL CD-ROM

As we mentioned in the introduction to this section, the human figure and face can have a striking effect on the impact of a design.

Undoubtedly, the most dominant single element of these pages from GR/DD's CD for Central Saint Martins College is the silhouette interacting with imaginary touch screen technology (from inside the screen). Regardless of scale, this T-shirt-wearing male figure still arrests the viewer, due mainly to its density of color and deepness of tone.

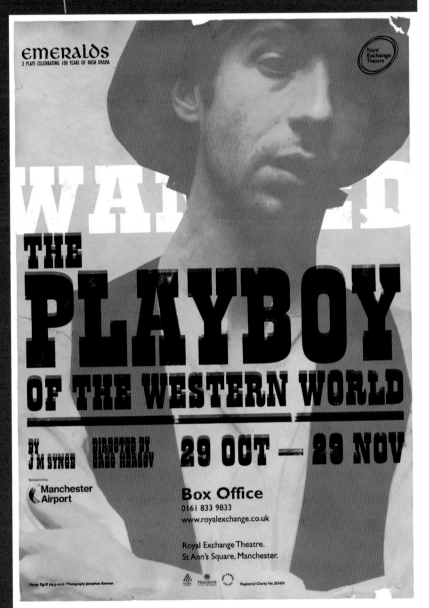

EG.G

THE PLAYBOY OF THE WESTERN
WORLD THEATER POSTER

Eg.G have dramatically merged image and text in this poster to attract the attention of passersby. A closely cropped photograph of the hero is viewed simultaneously with large, slab-serif type that runs both behind the head and across the chest, where tonal values make the words almost indistinguishable. After the initial impact, a number of levels of information emerge, from smaller type containing further details, to visual references of the American Wild West and its unsophisticated, "old-fashioned" printing techniques, including misregistered colors.

CLIENT	DESIGN	TYPOGRAPHY
ROYAL EXCHANGE	PAUL	PAUL
THEATRE	HEMMINGFIELD	HEMMINGFIELD
MANCHESTER UK		

ART DIRECTION	PHOTOGRAPHY
PAUL	JONATHAN KEENAN
HEMMINGFIELD	

CLIENT	DESIGN	TYPOGRAPHY
QUANTUM PUBLISHING	TOM ELSNER	TOM ELSNER

COPYWRITING	ART DIRECTION
QUANTUM PUBLISHING	TOM ELSNER

BUREAU FOR VISUAL AFFAIRS
EYE MAGAZINE WEB SITE

The *Eye* Web site is an index of current and past issues of *Eye* magazine and includes a monthly critique on contemporary issues.

Each page has an enticing and changing style, for the most part due to varying use of imagery and grid. Always acting as a starting point for accessing pages, and often linked to navigation systems, images have a colorful mix of scale and positioning.

The interactive index allows the viewer easy access to the entire range of back issues, and with such a variety of designs within their pages, large numerals, color coding, and a consistent design approach have been adopted to instantly inform the viewer as to which issue is displayed.

CLIENT
MFI

DESIGN
ANDY SPENCER

TYPOGRAPHY
ANDY SPENCER
MANJA HELLPAP

ART DIRECTION
DAVID STOCKS
GILMAR WENDT

PHOTOGRAPHY
MATT STUART

SAS
MFI ANNUAL REPORT

Creating a design that will be noticed and remembered was one of the primary aims of Andy Spencer and the team from SAS. The "true life" photographic record of the Spencer's stay in one of MFI's stores features prominently in this report, avoiding the usual shots of key management personnel and achievements from the previous year. The reader of the report cannot help but be drawn to the photo album–style pages that chart the family's stay, if only to see humorous interaction with the public, or to find out if sullen daughter Hannah warms to life in the MFI goldfish bowl.

WILSON HARVEY
JAMES MARTIN INSTITUTE OVERVIEW

"This brochure is not designed to be read from cover to cover," says Paul Burgess from Wilson Harvey, "but to convey a feel of what the institute is about." In order to achieve this, predominantly large-scale black-and-white photographic images stretch across the pages, oozing quality, power, and innovation. On each spread these shots, whether of architecture, people, or landscapes, sweep the focus around the composition to take in small, full-color images; information highlighted with orange; captions; and text.

CLIENT	DESIGN	ART DIRECTION
JAMES MARTIN INSTITUTE	WILSON HARVEY	PAUL BURGESS

→ CIVILIZATION AROUND THE WORLD WILL CHANGE DRAMATICALLY DURING OUR LIFETIMES AND THOSE OF OUR CHILDREN → THE JAMES MARTIN INSTITUTE WILL IDENTIFY THE CRITICAL ISSUES LIKELY TO SHAPE THOSE LIFETIMES → IT BRINGS TOGETHER THE BEST SCHOLARS AND PRACTITIONERS FROM BUSINESS, GOVERNMENT AND ACADEMIA TO CREATE A BETTER UNDERSTANDING OF HOW SCIENCE CAN BE USED FOR THE BETTERMENT OF RAPIDLY EVOLVING CIVILIZATIONS →CHALLENGE

The Institute arises at an exciting moment in the evolution of civilization. Scientific and technological change is occurring at an unprecedented pace and with enormous breadth. Can humanity ensure that it has the collective wisdom and intelligence to cope with it?

Global warming and the depletion of freshwater resources seem unstoppable. Advances in genomics and nanotechnology will bring important changes to our world. The possibility that the human body itself can be radically reengineered raises powerful questions about the role of technology in the development of future civilization.

Issues encountered in developing a global governance regime for genetic technologies illustrate the challenge of developing systems of management and governance for new technologies.

WHAT PRINCIPLES SHOULD GUIDE OUR CHANGING CIVILIZATION?

ALL TECHNOLOGIES HAVE THE POTENTIAL FOR GOOD AND EVIL.

CAN WE RECONCILE SHORT-TERM BUSINESS IMPERATIVES WITH LONG-TERM PROVISION OF FOOD?

WHO IS RESPONSIBLE FOR SETTING THE GOALS?

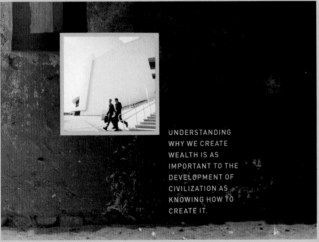

UNDERSTANDING WHY WE CREATE WEALTH IS AS IMPORTANT TO THE DEVELOPMENT OF CIVILIZATION AS KNOWING HOW TO CREATE IT.

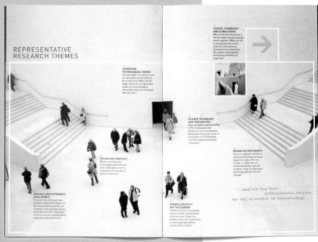

REPRESENTATIVE RESEARCH THEMES

Attention to the finer aspects of content and structure is demonstrated by this section taken from one of the spreads. A squared-up inset shot invites the reader's attention initially, as it sits on the same eye-level as a figure in the main photograph, and is framed by a light orange border. It then holds their attention because it embodies intriguing contrasts of scale and a reversal of the black and white in the large image, with two tiny, almost black figures set against a curved expanse of white wall. Cohesion and coherence are further achieved through subtle repetitions of the square format—in the windows of the white building, in the old wall of the main shot, and in the proportions of the block of text.

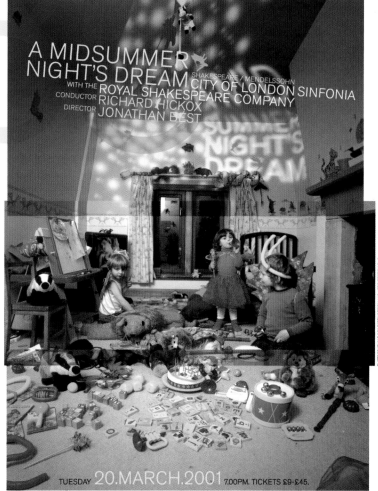

EG.G
A MIDSUMMER NIGHT'S DREAM
CONCERT POSTER

A lively mix of bright colors attracts viewers to this poster, which at first glance portrays a child's cluttered bedroom. A wide audience can identify with this familiar scene, and because the principle typography has been projected onto the wall of the room, it is perceived as an integral part of the image, achieving a striking advertising poster. As Dom Raban of Eg.G explains, "On closer examination, every element within the room is a coded reference to Shakespeare's narrative." An exciting part of creating different levels of information is being able not only to hold interest, but also to heighten intrigue so that the design becomes interactive, memorable, and, in this case, successful in enticing viewers to read the functional information, and attend the play.

CLIENT	DESIGN	TYPOGRAPHY
CITY OF LONDON SINFONIA	DOM RABAN	DOM RABAN

ART DIRECTION	PHOTOGRAPHY
DOM RABAN	GAVIN PARRY

CLIENT	DESIGN
NIKON	MIRKO ILIC

ART DIRECTION	PHOTOGRAPHY
MIRKO ILIC	BRUCE DATE

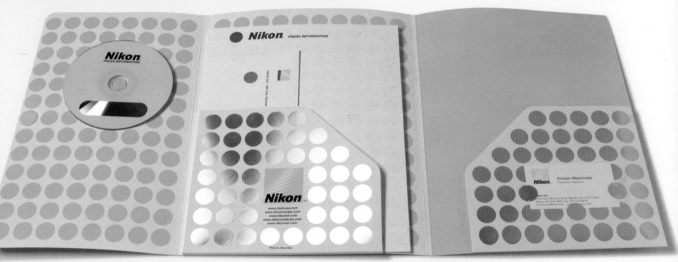

MIRKO ILIC CORP
NIKON PRESS KIT

"This Nikon press kit had two objectives," says Mirko Ilic. "To catch the eye of the audience, and to play with the element of light, since cameras and photography are based on light." It is probably the synergy of repetitive, patterned circles on a holographic foil that attracts initially, as it is unusual and constantly changing depending on the environment and on the viewer's movements. However, two "need to know" questions are triggered; who is this piece for, and what is the image in the color-coordinated circles? The namestyle and brand colors of Nikon are likely to be perceived next as they are familiar, and the landscape image that runs as though behind the circles is finally recognized through intrigue and sheer persistence. The opened folder works cleverly with variations on the established visual theme. Pockets printed with holographic dots contain sheets of letterhead paper that have "the landscape dots" printed on their reverse, and a large yellow circle—a CD—is affixed on a background of yellow dots.

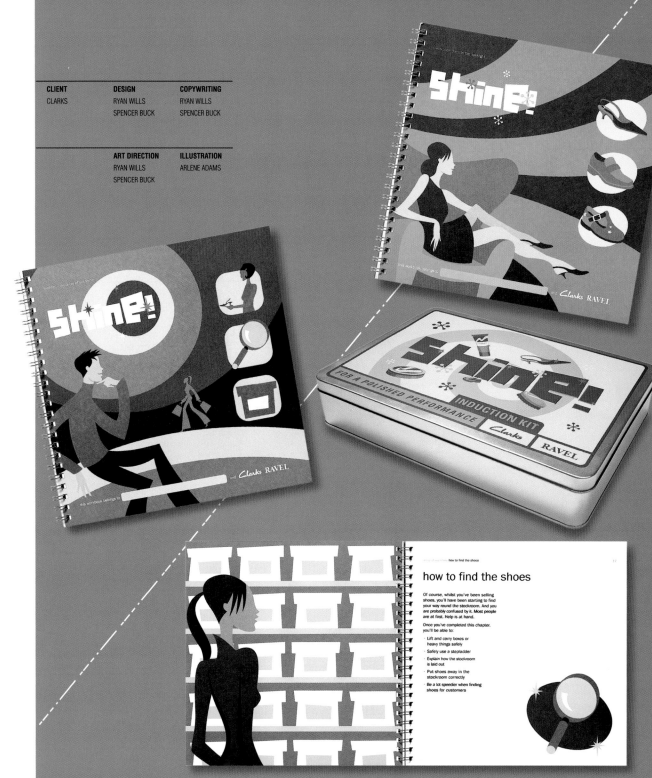

CLIENT	DESIGN	COPYWRITING
CLARKS	RYAN WILLS	RYAN WILLS
	SPENCER BUCK	SPENCER BUCK

	ART DIRECTION	ILLUSTRATION
	RYAN WILLS	ARLENE ADAMS
	SPENCER BUCK	

how to find the shoes

Of course, whilst you've been selling shoes, you'll have been starting to find your way round the stockroom. And you are probably confused by it. Most people are at first. Help is at hand.

Once you've completed this chapter, you'll be able to:

· Lift and carry boxes or heavy things safely
· Safely use a stepladder
· Explain how the stockroom is laid out
· Put shoes away in the stockroom correctly
· Be a lot speedier when finding shoes for customers

TAXI STUDIO LTD.
SHINE!, EMPLOYEE INDUCTION KIT

By selecting Arlene Adams' brightly colored, fifties-style illustration and a less wordy approach for this induction kit, Taxi Studio are appealing to Clarks' employees in a friendly and effective way. The first thing employees will see are the bold images; dominating each spread (they fill at least 50 percent of the space), these are created with large areas of flat color, drawn from a limited palette. The supporting copy is seen next, printed in small, black, sans-serif text, with headings all in lowercase.

The Sociology of Mental Disorders

WILLIAM W. EATON

Third Edition

CLIENT
GREENWOOD
PUBLISHING

DESIGN
AMY KWON

ART DIRECTION
L. RICHARD POULIN

PHOTOGRAPHY
DEBORAH KUSHMA

POULIN + MORRIS INC.
THE SOCIOLOGY OF MENTAL
DISORDERS, BOOK COVER

Poulin + Morris' cover design for *The Sociology of Mental Disorders* uses two different images of the human head—one an x-ray, the other a closely cropped portrait—to arrest the reader. The images are printed in contrasting colors and type is kept to a minimum. The viewer's focus is drawn first to the dark blue portrait and book title; this sits upon a mustard background that accommodates the x-ray. This x-ray, an image of a scull, is seen next, along with the author's name.

CLIENT	DESIGN	TYPOGRAPHY
THE WIRE	KJELL EKHORN	KJELL EKHORN
MAGAZINE	JON FORSS	JON FORSS

ART DIRECTION	PHOTOGRAPHY
KJELL EKHORN	JO ANN TOY
JON FORSS	ROBERT
	GALLAGHER
	ANNA SCHORI

NON-FORMAT
MATMOS, MAGAZINE SPREAD

This issue of *The Wire* magazine features many very striking full-page portraits, all of which grab the reader's attention ahead of any type. Viewed next, even headings take on an image bias, as they are embellished illustratively with silhouetted snippets of fraying fabric to create a complex, delicate, and somewhat organic effect. Completing the three layers present within these spreads, smaller, introductory text is seen after photography and headings.

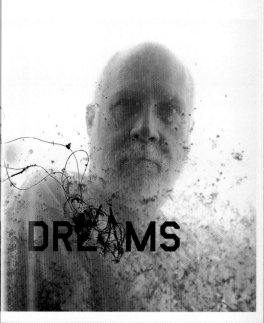

YANKEE DOODLE DANDIES

When they're not traipsing round the world as core members of Björk's backing group, or completing studies in Renaissance literature, San Francisco duo Matmos remain devoted to sourcing sounds from a wide range of topically and historically resonant objects. Martin C Schmidt (left) and Drew Daniel talk David Toop through the potent brew of British and American folk, medieval instruments and domestic disturbance that makes up their new album, *The Civil War*. Photos: Jo Ann Toy

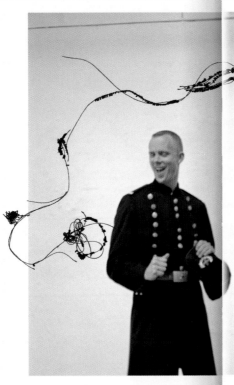

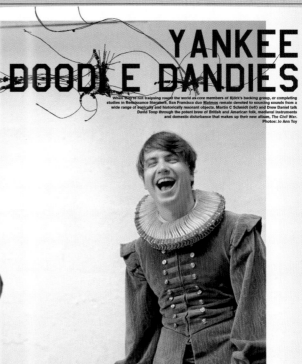

ANTI--ROCK CONSORTIUM

Although he's been a globally renowned artist for two decades, Mike Kelley's parallel career in music and sound art is a story rarely told. It is a tale that begins in Detroit with the post-Stooges punk noise insurgency of Destroy All Monsters, and winds up in Los Angeles via conceptual rock mythmaking with Tony Oursler in The Poetics, and collaborations with Sonic Youth, Scanner and Jean Baudrillard. Words: Edwin Pouncey. Photos: Robert Gallagher

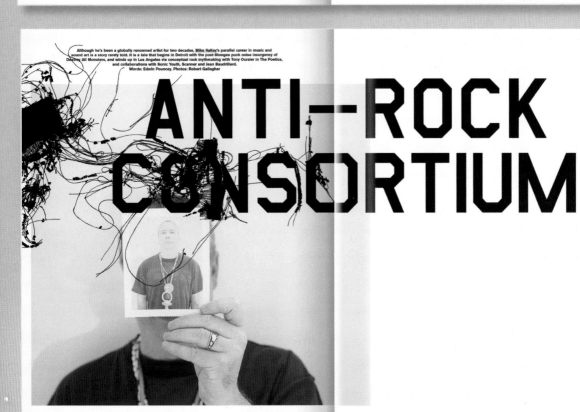

CLIENT	DESIGN	ART DIRECTION
TATE BRITAIN	NICK VINCENT	ALAN DYE
		BEN STOTT
		NICK FINNEY

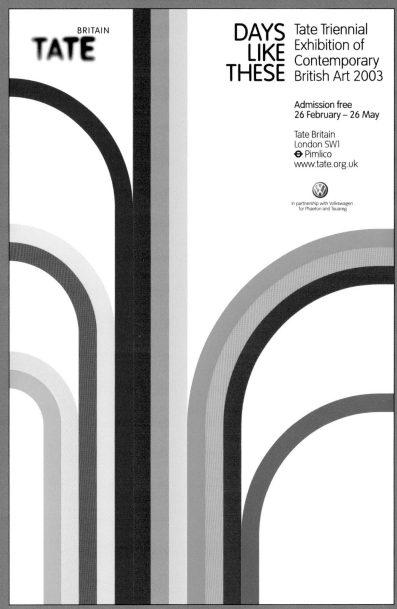

NB: STUDIO
DAYS LIKE THESE

Reminiscent of London's Underground map, the brightly colored, swirling lines that make up the main focus of this design for Tate Britain's Days Like These exhibition are not only very prominent, they also act as an effective wayfinding system. "The show features the work of 23 British artists, and instead of being located in one distinct gallery, the pieces were dotted throughout the Tate," says Alan Dye of NB: Studio. Certain designs, like the London Underground map, have become icons, and are instantly recognized by UK citizens and visitors alike; if designers can tap into their familiarity by replicating distinctive aspects, they can also take advantage of their ability to attract attention. Each item clearly belongs to the same set, with different sections of the enlarged, colored network taking center stage, in a position of primary focus.

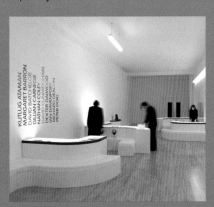

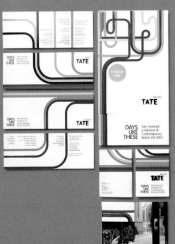

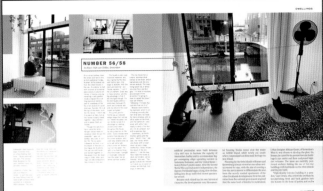

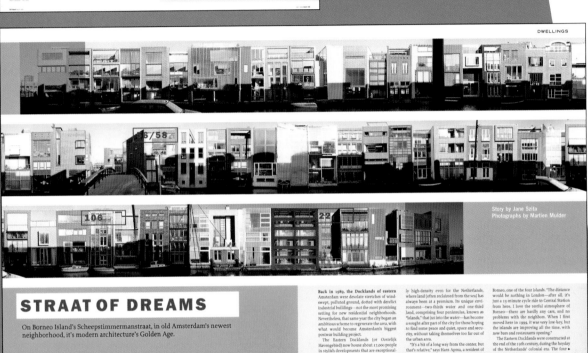

Story by Jane Szita
Photographs by Martien Mulder

STRAAT OF DREAMS

On Borneo Island's Scheepstimmermanstraat, in old Amsterdam's newest neighborhood, it's modern architecture's Golden Age.

Back in 1989, the Docklands of eastern Amsterdam were desolate stretches of wind-swept, polluted ground, dotted with derelict industrial buildings—not the most promising setting for new residential neighborhoods. Nevertheless, that same year the city began an ambitious scheme to regenerate the area, with what would become Amsterdam's biggest postwar building project.

The Eastern Docklands (or Oostelijk Havengebied) now house about 17,000 people in stylish developments that are exceptionally high-density even for the Netherlands, where land (often reclaimed from the sea) has always been at a premium. Its unique environment—two thirds water and one third land, comprising four peninsulas, known as "islands," that jut into the water—has become a sought-after part of the city for those hoping to find some peace and quiet, space and security, without taking themselves too far out of the urban area.

"It's a bit of a long way from the center, but that's relative," says Hans Apma, a resident of Borneo, one of the four islands. "The distance would be nothing in London—after all, it's just a 15 minute cycle ride to Central Station from here. I love the restful atmosphere of Borneo—there are hardly any cars, and no problems with the neighbors. When I first moved here in 1999, it was very low-key, but the islands are improving all the time, with new bars and restaurants opening."

The Eastern Docklands were constructed at the end of the 19th century, during the heyday of the Netherlands' colonial era. The four ▶

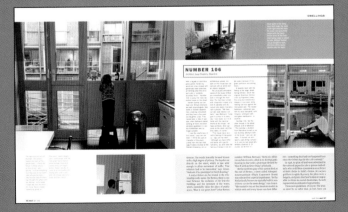

DWELL DESIGN DEPT.
STRAAT OF DREAMS, MAGAZINE SPREAD

The horizontal row of brightly colored, terraced houses together with the blocks of orange and blue immediately attract viewers to these spreads. Due to the comparatively small scale, the initial perception is purely one of an exciting mix of pattern and carefully selected colors. The impact, however, is sufficiently powerful to secure most readers' desire to decode the content of the images alongside main headings, and finally to embark upon the text.

CLIENT
DWELL MAGAZINE

DESIGN
JEANETTE HODGE ABBINK

COPYWRITING
JANE SZITA

ART DIRECTION
JEANETTE HODGE ABBINK

PHOTOGRAPHY
MARTIEN MULDER

PHOTO EDITOR
MAREN LEVINSON

BUREAU FOR VISUAL AFFAIRS (BFVA)
WORDAFFAIRS WEB SITE AND IDENTITY

There is no doubt that the striking landscape imagery used in the WordAffairs Web site is hierarchically dominant. "The Web site splits the aspirational image-based content and the pure information into two separate entities, while the content remains easy to access, read, and navigate, and the imagery is given space and prominence," says Simon Piehl of BfVA.

CLIENT	DESIGN	TYPOGRAPHY
WORDAFFAIRS	SIMON PIEHL	SIMON PIEHL
	TOM ELSNER	TOM ELSNER

COPYWRITING	ART DIRECTION	PHOTOGRAPHY
WORDAFFAIRS	SIMON PIEHL	SIMON PIEHL
BFVA	TOM ELSNER	

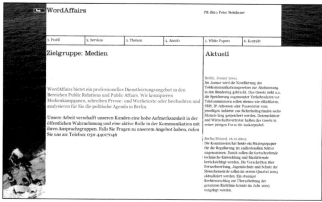

CLIENT	DESIGN
MUNTHE PLUS SIMONSEN	PER MADSEN MUGGIE RAMADANI

ART DIRECTION	PHOTOGRAPHY
PER MADSEN	RASMUS MOGENSEN

SCANDINAVIAN DESIGN GROUP
MUNTHE PLUS SIMONSEN
SPRING/SUMMER 04 CATALOG

As with many fashion catalogs, the Scandinavian Design Group's work for Munthe plus Simonsen's spring/summer 04 collection features primarily image-based design. However, unlike many other pieces, images and backgrounds have been manipulated to create a kaleidoscopic effect intent on fascinating the viewer and drawing them in to the deepest level of imagery. Models are reflected and duplicated, as are backgrounds, echoing the angles and structure of the clothing featured to create a space-age environment.

CLIENT	DESIGN	TYPOGRAPHY
UNI GALLERY OF ART	PHILIP FASS	PHILIP FASS

COPYWRITING	PHOTOGRAPHY
DARRELL TAYLOR	PHILIP FASS
MARY FRISBEE	
JOHNSON	

PHILIP FASS
FALL 2001 UNI
(UNIVERSITY OF NORTHERN IOWA)
GALLERY OF ART SCHEDULE POSTER

The passing viewer is drawn to this gallery schedule by its dramatic use of color, large-scale imagery, and five striking, dark blue bands sitting horizontally across the center of the piece. Slightly lighter turquoise tones are used for the giant snowflake and flower images that make up the background layer of this poster. Descriptions of events and program details are not initially evident, but are "easy to read when pausing in front of the poster," says Philip Fass.

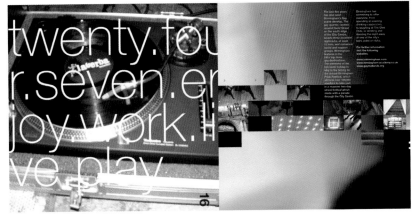

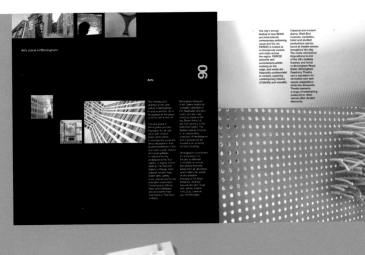

CLIENT
UNIVERSITY OF
CENTRAL ENGLAND
(UCE)

DESIGN
RICHARD HUNT
SCOTT RAYBOULD

Z3 DESIGN STUDIO INC.
UNIVERSITY OF CENTRAL ENGLAND
ART AND DESIGN PROSPECTUS

Shooting their own digital imagery for this prospectus enabled the designers at Z3 to focus on many abstract details, while highlighting color and texture. The viewer is drawn first to the colorful full-page shots, often located opposite contrasting, all-black pages. The reader is drawn next to the smaller, squared-up images, which have as much bright color detail as their larger counterparts. Color plays a vital role within this design—bright, acidic hues were sought out by Richard and Scott—though full-page photographs are always handled so that type, despite being viewed last, is clearly legible set on top of image.

HIERARCHY AND MANIPULATION WITH IMAGERY

Comment upon much of the image-driven work shown in this section is about powerful or significant subject matter that impacts upon the hierarchical structure of a layout. Challengingly, in many designs, the most eye-catching image is not necessarily intended to be the primary attention grabber; designers may need to create visual emphasis where it is appropriate, rather than where it naturally occurs. Exercise 06 provides an opportunity to experiment with different design alternatives that might solve this problem, and to consciously question and analyze the results—these may be unexpected.

Three full-color images—a landscape, a bowl of fruit, and a head-and-shoulders portrait—must all be included in each composition, within an A5 (8¼ × 5¾in/ 210×148mm) format, but with changing priorities. Three disparate images have been chosen, as this forces different design tactics to achieve the desired results.

1. Produce a minimum of five alternatives that show the figure as the dominant element in the layout.

2. Produce five more, making the bowl of fruit the most significant.

3. Finally, produce five in which the landscape appears as the main attraction.

Make the layouts in each group as different as possible in order to encourage more unusual and less predictable solutions. As an extra challenge, sequence images two and three, as opposed to accepting them as equal second.

Manipulations that involve changes of scale in terms of picture boxes and image content are permissible, plus squared-up or shaped boxes, as well as cut-out versions, overlapping, cropping variations, and the addition of frames. While changing tonal values or color hues are viable options, in the context of this exercise, they will only serve to obscure the conclusions.

FIG. 1

FIG. 5

In figs. 1–4, compositions show the head-and-shoulders portrait as the most dominant element. As faces tend to draw the eye, more subtle design techniques of layout, cut-outs, framing, and overlapping, as opposed to increasing scale, can be used to attract attention.

Figs. 5–8 make the bowl of fruit the most impactive, largely by making it big enough to take advantage of its brightness of color. In two of the compositions, the head-and-shoulders images are considerably larger than in figs. 1–4, yet the fruit is still likely to be seen first.

In figs. 9–12, the landscape must dominate. This is probably the hardest part of the exercise as landscapes are expected to form backdrops rather than focal points. However, contrasts of scale, shaped boxes, and an overlapping, white-framed picture box help to construct four successful concepts.

FIG. 9

FIG. 2

FIG. 3

FIG. 4

FIG. 6

FIG. 7

FIG. 8

CLIENT
SURFACE
MAGAZINE

DESIGN
RICHARD SMITH

ART DIRECTION
RILEY
JOHNDONNELL

PHOTOGRAPHY
TIZIANO MAGNI

EXQUISITE CORPORATION
LOVE ME KNOTS, MAGAZINE
FASHION FEATURE

The pages of "Love me Knots" show various models, clad in couture outfits and bound with different shades of thick rope. If all of this and the eye-catching pair of red wedge platforms shown on the opening spread are not enough to arrest the viewer, Richard Smith has added some striking white, rectangular shapes that cut into the photographs and, as the lightest elements in tone, also attract the reader's attention.

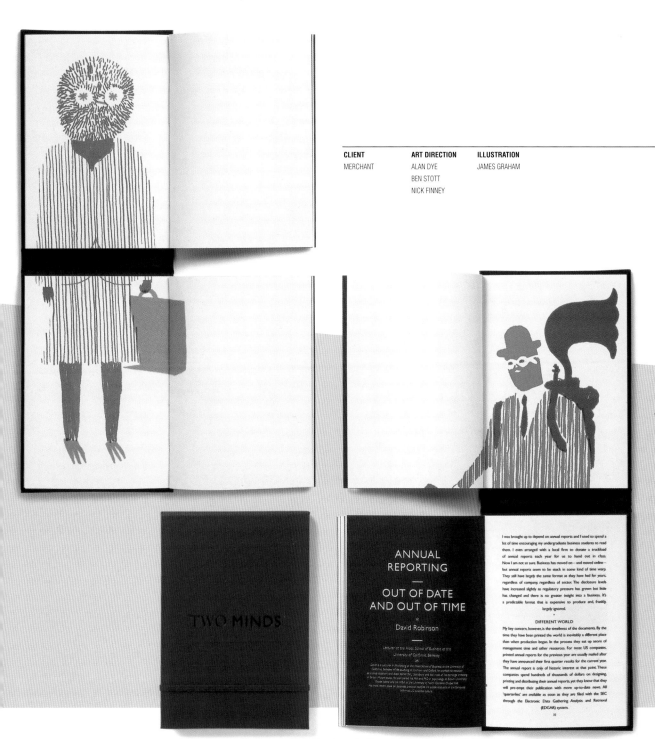

CLIENT
MERCHANT

ART DIRECTION
ALAN DYE
BEN STOTT
NICK FINNEY

ILLUSTRATION
JAMES GRAHAM

NB: STUDIO
TWO MINDS,
MERCHANT HANDBOOK 2003

The classic moleskin notebook provided the inspiration for the design of *Two Minds*, the Merchant Handbook for 2003. The cover lifts up to reveal two separate volumes, one above the other, and this format is one of the most noticeable elements of the piece. Separate spreads from each volume combine to reveal James Graham's lighthearted illustrations and attract the attention of the reader, giving them the engaging task of finding and locating the other half of each image.

Photographs by Evan Dion

CLIENT
EVAN DION
PHOTOGRAPHY

DESIGN
CLAUDIA NERI

ART DIRECTION
CLAUDIA NERI

PHOTOGRAPHY
EVAN DION

TEIKNA GRAPHIC DESIGN INC.
VENEZIA L'INVERNO

"This is a very image-driven piece," says Claudia Neri of Teikna Design. "It is aimed at making an emotional connection with the viewer. Text is used as a complement, a personal afterthought, or commentary to the images," she continues. Supporting type is well selected and merges with the imagery; its elegance relates appropriately not only to the style of photography, but also to the subject matter itself.

PHILIP FASS
PRAIRIE DREAMS EXHIBITION
INVITATION

This invitation to Prairie Dreams reflects the exhibition's installation of living plants. The dominant images of prairie grass definitely draw the viewer's attention first, with type playing a secondary, but nonetheless interesting role. "The type moves through the image in a poetic manner," says Philip Fass. "In the collection of information, the reader's eyes enact a motion across the surface of the card that is related to the movement of wind across the prairie," he continues. Type, though secondary, is easy to access, as the strong use of yellow and green within the photographs contrasts with, and draws attention to, small amounts of blue text located primarily at the upper edge of the page. The expectation of blue skies extending in this position also helps to ensure that viewers read this information.

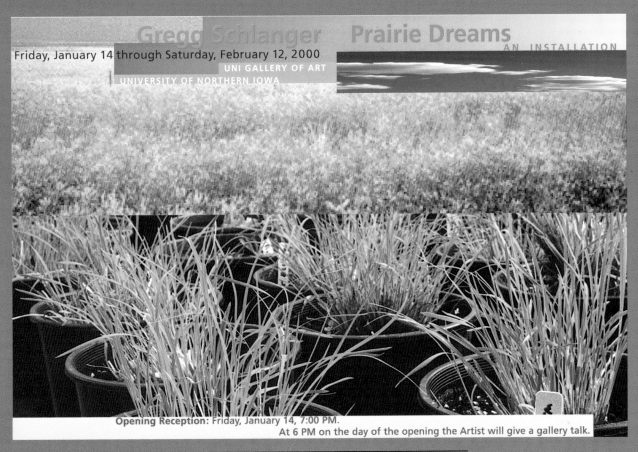

Gregg Schlanger Prairie Dreams
AN INSTALLATION

Friday, January 14 through Saturday, February 12, 2000
UNI GALLERY OF ART
UNIVERSITY OF NORTHERN IOWA

Opening Reception: Friday, January 14, 7:00 PM.
At 6 PM on the day of the opening the Artist will give a gallery talk.

CLIENT	DESIGN	TYPOGRAPHY
UNI (UNIVERSITY OF NORTHERN IOWA) GALLERY OF ART	PHILIP FASS	PHILIP FASS

ART DIRECTION	PHOTOGRAPHY
PHILIP FASS	PHILIP FASS
	GREGG SCHLANGER

CLIENT
BABES IN TOYLAND

DESIGN
ANDREW DEBENS

Z3 DESIGN STUDIO, INC.
BABES IN TOYLAND, CD PACKAGING

Andrew Debens of Z3 has created a new identity and typeface for the group Babes in Toyland, to be implemented across three albums of past, present, and future works. Designs are dominated by a strong use of color and layered montages of distressed images, with Deben's new typeface being seen second, as a support to this complex and evocative imagery.

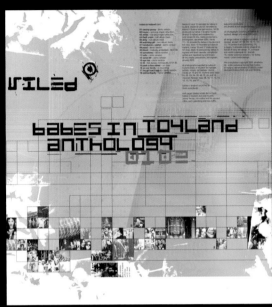

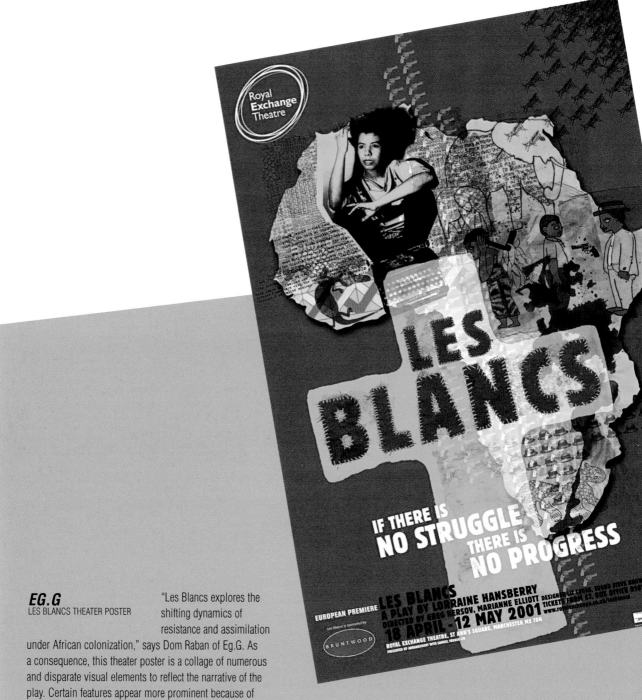

EG.G
LES BLANCS THEATER POSTER

"Les Blancs explores the shifting dynamics of resistance and assimilation under African colonization," says Dom Raban of Eg.G. As a consequence, this theater poster is a collage of numerous and disparate visual elements to reflect the narrative of the play. Certain features appear more prominent because of their scale and tonal definition; however, just as the play is about changing power, so much of the poster is made up of overlays of visual and verbal information that vie for attention, with changing emphasis dependent on the viewer's personal knowledge and experience.

CLIENT	DESIGN	ART DIRECTION
ROYAL EXCHANGE THEATRE, MANCHESTER UK	DOM RABAN JO MORRITT	DOM RABAN

ODED EZER
DESIGN STUDIO
NOW POSTER

Oded Ezer's poster has been produced in homage to the work of Israeli visual communicator David Tartakover. The title "Now" makes reference to the Israeli peace movement slogan, "Peace Now." At first sight, the viewer is confronted by a dense shower of disturbingly sharp nails falling from the sky. However, on closer inspection, a layered effect provides the opportunity to look through this storm and, in the distance, view nails that have come together to create 3-D letterforms.

CLIENT	DESIGN	TYPOGRAPHY
SELF-PROMOTIONAL PROJECT	ODED EZER	ODED EZER

ART DIRECTION	PHOTOGRAPHY
ODED EZER	SHAXAF HABER

CLIENT
SPEEDY HIRE

DESIGN
NICK VINCENT

ART DIRECTION
ALAN DYE
BEN STOTT
NICK FINNEY

PHOTOGRAPHY
PHIL SAYER

NB: STUDIO
SPEEDY HIRE, ANNUAL REPORT & ACCOUNTS 02

By overlaying Phil Sayer's gritty black-and-white photography of Speedy Hire's everyday activities with type that takes on the characteristics of warning stickers, NB: Studio have created some colorful, eye-catching spreads within this report and accounts publication. The large-scale shots certainly attract the reader's attention first, while the remaining layers of information are provided by a collage of the colored stickers that accommodate copy, each given a different treatment.

This elemental $150,000 metal and plywood pavilion is not everyone's idea of a shack, but it's a
reminder of a time when summer houses in East Hampton were all about sand and sea.

The Perfect Beach Shack

Strangeness
by the Sea

At 10 P.M. on a January evening in Acuileo, Chile, dark-
ness is finally settling over a 19th-century patio. Cristalla
crabmeat and vodka cocktails are on the table. The chil-
dren are asleep with a nanny. Birds are making soft noises,
and somewhere distant, someone is playing a George
Harrison record. But otherwise, in this pastoral place 40
miles south of Santiago, it is quiet. Mathias Klotz is sitting
on a bench with his wife, Magdalena. Magdalena's family
surround them. Mathias is stalking a golf ball onto an
old leather glove and stretching the worn material around
the ball to sculpt a face. The face is silly and Magdalena
smiles. Later on at the dinner table, Mathias snuffs a nap-
kin ring over his sleeve, and observes his wife's strange
new growth while he reaches for the salt.

Among the under-40 college-educated population of
Chile, Mathias Klotz is a celebrity—as much for the
profound, prolific nature of his architectural work as for
Chileans' avid interest in design. Kin o the 1970s, the
architecture frenemies of Santiago have drawn hundreds

of curious eyes on him too. The Universidad Católica in
Santiago has one of the four oldest architecture schools in
the Americas. And young architecture buffs love to tell
stories about the avant-garde Valparaíso school of the mid-
20th century, where, among other things, a professor
once showed up for his class wearing a spanken mustard
stuffed with variously shaped blocks, to demonstrate
volumes. That image comes to mind while Mathias plays
with his napkin ring—although he was educated at the
Universidad Católica in Santiago, in the early 1980s, not at
Valparaíso.

The next morning, Mathias drinks a strong cup of tea in
the kitchen while Magdalena pings on a laptop and the
modern makes its aggravating, necessary noise. Collecting
some briefcases and plans, we hasten to the Jeep I take
the backseat. The engine needs a jump-start. After some
Longfoot and requisite curses over Juniper cables, we're on
our way to a morning of usual business in Santiago, visit-
ing project sites to talk with contractors. In the afternoon ►

DWELL DESIGN DEPARTMENT
STRANGENESS BY THE SEA/
THE PERFECT BEACH SHACK,
MAGAZINE FEATURES

The arrangement of type and tinted boxes in both these spreads is inspired
by the color and composition of the images. This establishes the entire layout
as the first level of perception, and as one cohesive whole. Colors of words
match colors within images, and tinted boxes relate to each other and to text
in a way that reflects the constructional character of the buildings. The second level is provided by the
headline type, with the assimilation of body copy coming last.

CLIENT	DESIGN	COPYWRITING	ART DIRECTION	PHOTOGRAPHY	PHOTO EDITOR
DWELL MAGAZINE	SHAWN HAZEN	VIRGINIA GARDINER	JEANETTE HODGE	CLAUDIO EDINGER	MAREN LEVINSON
	JEANETTE HODGE	VICTORIA MILNE	ABBINK	AMY ECKERT	
	ABBINK				

SCANDINAVIAN
DESIGN GROUP
NOVO NORDISK SERVICEPARTNER
BRAND IDENTITY

Mixing black-and-white and color photography across the spreads of this
miniature brochure for Novo Nordisk has helped The Scandinavian Design
Group create some striking spreads. These clearly image-driven pages blend
natural landscape with informal portrait photography in a successful manner.
Shots accommodate panels of handwritten script that make up the second level of this design, and more
formal panels of lightweight, sans-serif text that make up the third. Another level, created by the gloss varnish,
is perceived separately and, dependent upon the reader, this can be "seen" at any point in the viewing process.

Kundens succes er
vores omdrejningspunkt

Vi skal være sparringspartner for vores kunder og give dem
tid til at fokusere på de områder, de er bedst til.

Et samarbejde med Novo Nordisk Servicepartner skal betyde:

Højt serviceniveau // Fokus på det, virksomheden er bedst til //
Et skridt foran konkurrenterne // Positiv indflydelse på budgettet
// Objektiv rådgivning // Frigørelse af ressourcer // Skræddersyede
løsninger // Adgang til specialistviden og dygtige medarbejdere.

Palle Buller
Vagtassistent // NNS Sikring

CLIENT	DESIGN	ART DIRECTION	PHOTOGRAPHY
NOVO NORDISK SERVICEPARTNER A/S	MUGGIE RAMADANI	JESPER VON WIEDING	MIKKEL BACHE

Laboratorieløsninger

Steen Jürgensen
Servicemedarbejder

Visionen driver os

Novo Nordisk Servicepartners vision er at styrke vores kunders
konkurrenceevne ved at levere Facility Management rådgivning
og service.

Som en førende udbyder sætter vi standarden på markedet.
Baseret på unik faglig viden vil vi være hurtige til at analysere
og reagere på vores kunders behov med skræddersyede løsninger.

Vi ved, at langsigtet succes handler om mere end at give god
service til vores kunder:

Det er derfor, vi siger:

04 // 05

Z3 DESIGN STUDIO INC.

DANCE EAST CORPORATE BROCHURE

This almost entirely image based design for Dance East, by Scott Raybould of Z3, folds and flows to mimic the movement of dance. Images involve dramatic changes of scale, varied cropping, and vivid use of color. As to which image grabs the viewer's attention first, this is likely to be the single, large, bright-red image with its dramatic cropping and expansive use of space. However, the other imagery continues to lead the viewer quickly from one photo to the next, in an order that is probably dependent on personal preference.

CLIENT
DANCE EAST

DESIGN
SCOTT RAYBOULD

CLIENT	DESIGN	TYPOGRAPHY
THE SHINING	SIMON YUEN	JAMES BOWDEN
	JULIEN	
	DEPREDURAND	

COPYWRITING	ART DIRECTION	ILLUSTRATION	PHOTOGRAPHY
THE SHINING	JAMES BOWDEN	PAMELA HOLDEN	THE SHINING

GR/DD GRAPHIC RESEARCH DESIGN DEVELOPMENT
THE SHINING BAND WEB SITE

There is no doubt that large areas of black, injected with colored elements in bright primaries, really attract attention in this Web site designed for the band The Shining. "We wanted to create a 3-D TV broadcast environment with hidden channels and promo areas such as backstage filming and videos," says James Bowden of GR/DD. "The user is placed in a TV network environment in which, by using remote-control access, it is possible to explore various parts of the site," he concludes.

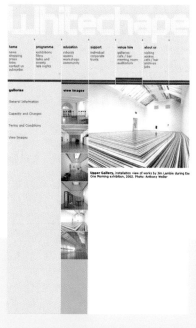

CLIENT	DESIGN	TYPOGRAPHY
WHITECHAPEL GALLERY	SIMON PIEHL TOM ELSNER	SIMON PIEHL TOM ELSNER

COPYWRITING	ART DIRECTION
WHITECHAPEL GALLERY	SIMON PIEHL TOM ELSNER

BUREAU FOR VISUAL AFFAIRS (BFVA)

WHITECHAPEL GALLERY WEB SITE

In order to ensure that the site is easily accessible, the navigation system is shown in every area of this Web site for the Whitechapel Gallery. Making a strong and well structured use of grid systems, each page uses imagery dramatically to dominate its hierarchy, enticing the browser into the site, there to engage with more detailed information on less visually prominent levels. Shots of gallery spaces and exhibitions are "thrown forward" by being set on muted background tones, and the namestyle runs across the width of each page.

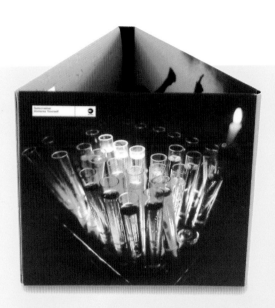

CLIENT
SONY MUSIC

DESIGN
RICHARD HUNT

Z3 DESIGN STUDIO INC.
GATECRASHER CD PACKAGING

Producing CD packaging with impact was a primary aim for Richard Hunt and Z3 when designing for Sony Music's *Gatecrasher*. The first element of the design that any viewer will notice is its extensive use of bright, primary yellow as a background color; this allows the small-scale, black text to be clear and readable. Z3 have also selected a shade of turquoise that, because it is "almost" complementary to the yellow, perpetuates the powerful, vibrant, and captivating effect. Both colors also have a distinct presence within the impactive, abstract photography that makes up the second level of this design.

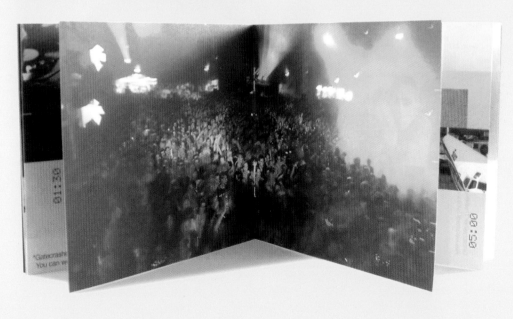

ART OF
THE GARDEN
3 JUNE –
30 AUGUST
TATE BRITAIN

Book your tickets now
on 020 7887 8888
or at www.tate.org.uk
⊖ Pimlico ⛴ Millbank Pier

BRITAIN
TATE

ART
OF
THE
GARDEN

Sponsored by
≡I ERNST & YOUNG

CLIENT
TATE BRITAIN

DESIGN
NB: STUDIO

ART DIRECTION
ALAN DYE
BEN STOTT
NICK FINNEY

NB: STUDIO
ART OF THE GARDEN EXHIBITION
POSTER

The arresting white silhouette of foliage from an English hedgerow provides an ideal "nest" for the title of this exhibition at Tate Britain— Art of the Garden. The group of leaves and branches eclipses all other elements, even when vying for supremacy with shots of Derek Jarman's fascinating Dungeness garden.

CLIENT	DESIGN	ART DIRECTION
MUNTHE PLUS	PER MADSEN	PER MADSEN
SIMONSEN	MUGGIE RAMADANI	

PHOTOGRAPHY	FILM
HENRIK BÜLOW	PHOTOGRAPHY
	PHILLIP KRESS

SCANDINAVIAN DESIGN GROUP
MUNTHE PLUS SIMONSEN
AUTUMN/WINTER 2003 CATALOG

The Munthe plus Simonsen autumn/winter 2003 catalog adopted a cinematic approach that has clearly affected the style and cropping of its imagery, and made it extremely seductive. Lighting is high contrast, often involving the use of colored gels, and images appear to be tightly cropped stills from a movie. The first thing the viewer will notice on picking up the catalog is the glossy, full-color acetate cover that flexes around this hardback issue. This entices them to leaf through the striking image-based spreads. The actual portraits are seen first, with the stylist's detailing and embellishments providing continued visual enjoyment on further levels.

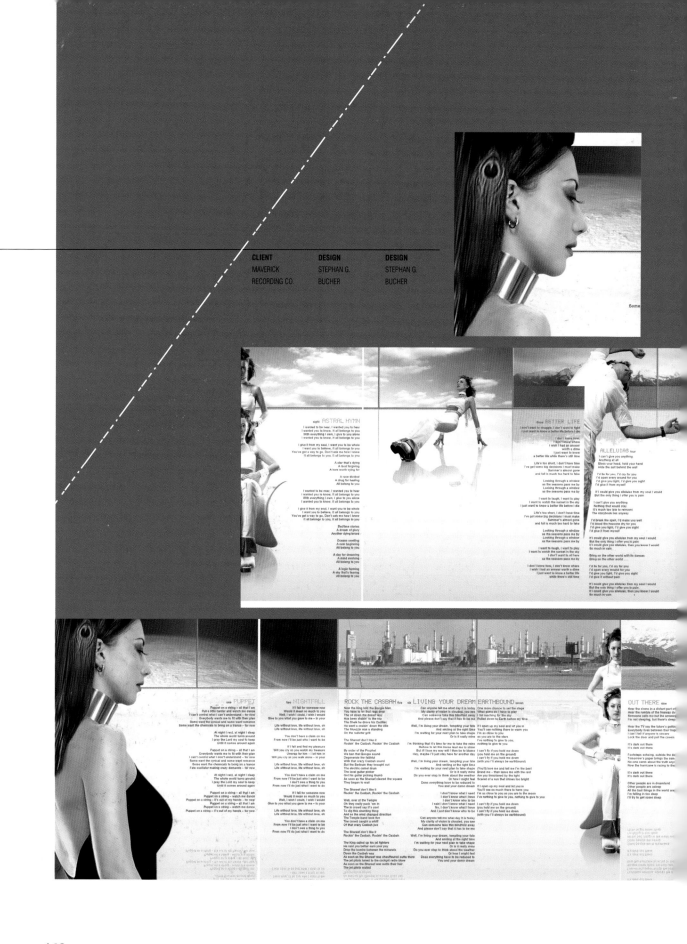

344 DESIGN, LLC
SOLAR TWINS CD PACKAGE

Unusually cropped and montaged images are the most visually powerful elements within this CD booklet design. The way in which Stephan Bucher has sliced figures in half, to provide vertical alignments for type, attracts attention, drawing the viewer into fascinating detailing with semi transparent sections and an intriguing interplay of foreground and background. Although the text flows in and around the images, as it is comparatively small, it is likely to be read last.

A peacock's feather, skillfully manipulated to blend into a model's hair, is just one of the surprises to be found as the viewer discovers more layers of information.

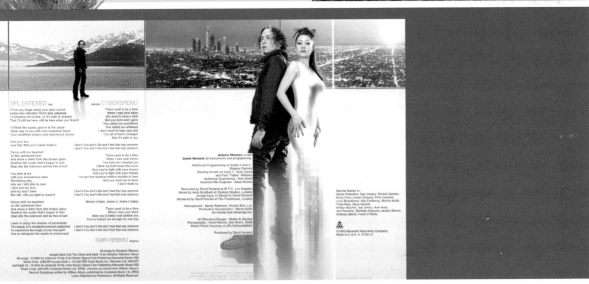

CLIENT
TEMPLETON
COLLEGE
UNIVERSITY OF
OXFORD

DESIGN
WAI LAU

ART DIRECTION
PAUL BURGESS

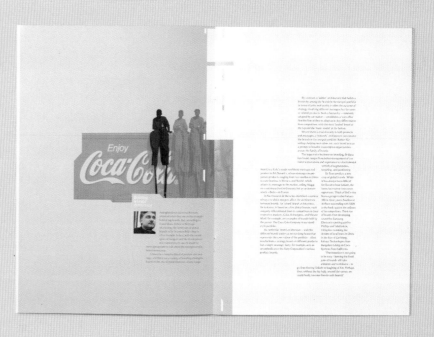

WILSON HARVEY
TEMPLETON REVIEW

This review is distinctive primarily because of its striking and unusual use of photography and composition. Comparatively predictable subject matter has been cropped in unexpected ways to give dynamic shapes that cut into, and line up with surrounding text; each image has been interpreted in a combination of single-color grayscale and full-color cut-out sections. The viewer's focus is drawn to the full-color sections, moves out to the monochrome areas, on into the background tints, and finally, with ease and a certain degree of willingness, into the text. With its changes of scale, column positions, and widths, the text is presented equally accessibly.

DIVERSITY WITHIN LAYOUT USING TEXT AND IMAGE

Although this book is divided into type-driven and image-driven ordering, this has not precluded combinations of image and type. This exercise provides an opportunity to consciously explore the ways in which hierarchical roles of both type and image interchange. In the examples below, images, headlines, and body copy come together in varied configurations to demonstrate some of the many possibilities available when designing pages.

Each example includes a constant number of elements that are combined in a variety of ways to create differing visual emphasis. Primarily, it is changes of composition and scale that control the reader's focus and visual route through a layout. This allows the origination of alternative pace and rhythm, and also introduces the possibility of altering meanings. Even paragraphs of text that are generally expected to be read last can be scaled and positioned so as to occupy a position of primary focus.

Photographs can be used as full-color images or as grayscale; type, as headings and subtext, can be used black on white or as white reversed through a background color, tint, or photograph. In order to produce design alternatives that concentrate on the relationships of type and image, it is beneficial to restrict the choice of typeface to the Helvetica family. Overly decorative or stylized typefaces could prove too much of a distraction and might have the effect of reducing the number of more skilled, sophisticated, and considered layout options. Images can be squared-up, cut-out, cropped, scaled, or repeated, and grayscale can be colored in order to highlight or knock back.

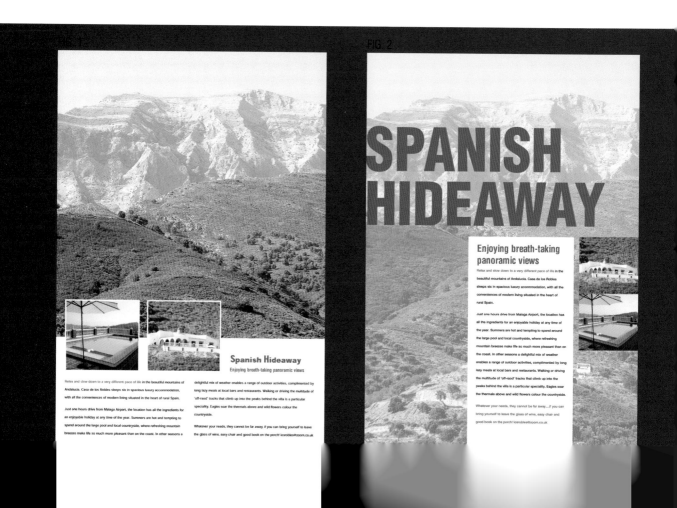

Impose the following parameters in the given order:

1. Create a number of image-driven A4 (8⅛ × 11¹¹⁄₁₆in/210 × 297mm) layouts, with the image content to be viewed first, the headlines perceived next, and body text to be seen last.

2. Create type-driven A4 layouts, with: a) the headlines reading first, the image content next, and finally the body copy; and b) the body copy as the most prominent element in the layout, the headlines read next, and the imagery seen last.

The benefit of this exercise comes from the experience gained through trial and error, not necessarily from creating the "best" layouts: the process of changing and fine-tuning treatments can provide unexpected results that feed into future work where hierarchical sequencing is important.

Fig. 1 demonstrates one of the many alternatives that can make images the most powerful components within a layout. The examples in Exercise 6 show different treatments that attract even more attention, but it is clearly evident that even when disregarding image content, the depth of tone and scale of images in relation to other elements tend to ensure their dominance.

Fig. 2 attempts to knock back the images to third place by overlaying a bold green headline on a single-color, grayscale image, and placing the smaller text in an overlaid white box. The headline catches the reader's attention, leads them to more green in the subheading, and on through all the type to the green concluding paragraph. The prominence of two color images is reduced by unobtrusive positioning and the use of comparable tonal and textural values with the background.

Figs. 3 and 4 are more challenging in that their text is intended to be the attention grabber. In fig. 3, the size of type, and the impact of white through blue and embedded white boxes draw the viewer in, but whether all the information is read before any of the imagery is absorbed is debatable. In fig. 4, the black-and-blue text is fairly large and positioned on an angle to appear more powerful. It may be seen first, but as the pictures are the most easily accessed elements, they will probably be taken in simultaneously.

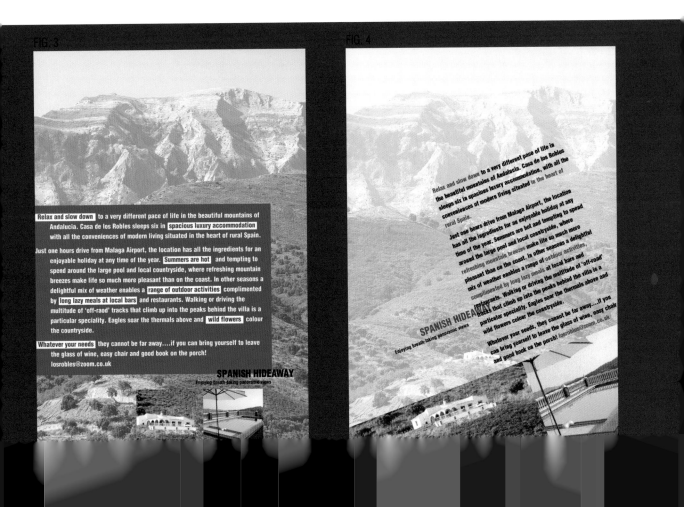

EG.G
DANCEWORKS BROCHURE

Dramatic cut-out images of energetic dance poses draw the viewer across and through the pages of this brochure. The compositions are clearly image-driven, to the extent that even the blocks of text and captions are seen initially as shapes that interact with the figures. Any actual reading of the type is likely to take place only after the complete spreads have been enjoyed as lively and stimulating experiences.

CLIENT	DESIGN	ART DIRECTION
DANCEWORKS UK	PAUL HEMMINGFIELD	DOM RABAN
	JO CARTWRIGHT	

04 FRI.31.JAN ROTHERHAM ARTS CENTRE

RJC DANCE PRODUCTIONS
7.30pm £7 / dancecard 25% off / £5 concs

SOMA MINDBODYSOUL

Take time out ¶ Forget about the stresses and strains of everyday living ¶ **Soma** will make you focus on the important things ¶ ...the perfect antidote to the impossible pace of modern life. ¶ Three talented choreographers have come together to explore the concepts of mind, body and soul and how they can be translated into movement. The result is surprisingly evocative, inspirational dance that is a departure from the company's signature 'street dance' styles. **Soma** will resonate with RJC's distinctive energy and dance form which draws its inspiration from reggae, jazz and contemporary dance techniques. ¶ *Powerful & empowering* — The Guardian ¶ *Phenomenal dancers* — Independent on Saturday

05 FRI.07 - SAT.08.FEB LYCEUM THEATRE

RICHARD ALSTON DANCE COMPANY
7.45pm £8.50 - £16.50 / dancecard 25% off / concs p22

STAMPEDE
A SUDDEN EXIT
TOUCH AND GO

Richard Alston makes dances which speak directly about movement and music and their combined power to move and elate. He is *a choreographer for whom every dance is a love affair with his chosen music* — The Times. The twelve dancers are wonderful exponents of his fluent, lively style and continue to attract critical and public praise wherever they perform. ¶ The Sheffield performances feature Alston's latest creation for his full company **Stampede**, [*hot, dark and dangerous dance* — The Guardian] set to the exotic Moorish-influenced sounds of Italian mediaeval music. **A Sudden Exit**, accompanied by Brahms's beautiful late piano music played live, is a truly moving work exploring the pain of abrupt departure - The Independent on Sunday hailed it as *a small masterpiece*. The evening climaxes with **Touch and Go** capturing the insistent pull of Argentinian tango. Astor Piazzolla's music provokes a mood of restless excitement and strange stirrings of repressed desire. ¶ *an unexpected pleasure...sheer, joyful spontaneity* – The Sunday Times.

EDUCATION WORK ON OFFER SEE P16

BEACH**BIRDS**

SERGEANT**EARLY'S**DREAM

THE**CELEBRATED**SOUBRETTE

06
RAMBERT DANCE COMPANY
LYCEUM £8.50 - £18.50 [£5 standbys] / concs P23 7.45PM WED.17 - SAT.20.JAN

Quite simply, the best — **The Mail on Sunday** ¶ **Beach Birds** inspired by images of seabirds, Merce Cunningham's hypnotic and sparsely beautiful approach *to dance.* ¶ *The dancers of Rambert are fantastic* — **The Times** ¶ **Sergeant Early's Dream** inspired by Irish, British and American folk music and songs, this suite of dances is both comic and poignant. For this nostalgic ballet, the nine dancers are joined on stage by The Sergeant Early Band. ¶ **The Celebrated Soubrette** A dazzling, Las Vegas inspired new work from the flamboyant choreographer Javier de Frutos. *A true audience pleaser* — **Daily Telegraph.** ¶ Free Pre-Performance Talk. Thu 16 Jan, 6.45pm in the auditorium.

Education Matinee — Swansong in Focus Thu 16 Jan at 2pm £6. ¶ **Rambert Education** In service training session Wed 17 Jan, 4 pm - 6 pm in Crucible Rehearsal Room. Open Workshop Sat 20 Jan, 10 am - 12 noon. For teenagers and adults with some dance experience. Tickets £8 from Rambert Education. ¶ Please send a large sae and cheque made payable to Rambert Dance Company to: **Rambert Education**, 94 Chiswick High Road, London W4 1SH. Workshops for schools, in-service sessions for teachers and educational resources please contact Rambert Education on 020 8994 2366 or e-mail rdc@rambert.org.uk

BAD**FAITH**AND**SYMBIOSI**

07
COLIN POOLE
ROTHERHAM ARTS CENTRE £6.50 / £4.50 concs 7.30PM TUE.30.JAN

A star is born and his name is Colin Poole — **Evening Standard** ¶ Two fabulous duets from the exceptional Colin Poole offer an evening of dance which will inspire and entertain. **Bad Faith** is provocative and comic, exploring seduction, sex and deceit. By contrast, **Symbiosis** has a powerful emotional quality and an eloquent movement language. ¶ Colin Poole has been a member of many of England's leading dance companies, notably **Phoenix** and **Rambert Dance** and is now recognised as one of the hottest new choreographers on the British dance scene. He was previously Associate Artist at The Place and is now Artist in Residence at Greenwich Dance Agency. ¶ *Highly concentrated and compelling* —**Sunday Times** ¶ In Bad Faith, he is joined onstage by Rachel Krische [Bedlam and Alleta Collins]. He performs Symbiosis with Heather Regio Duncan.

CLIENT	DESIGN
REPLAY & SONS	CHIARA
	GRANDESSO
	LIONELLO BOREAN

ART DIRECTION	ILLUSTRATION
CHIARA	CHIARA
GRANDESSO	GRANDESSO
	LIONELLO BOREAN

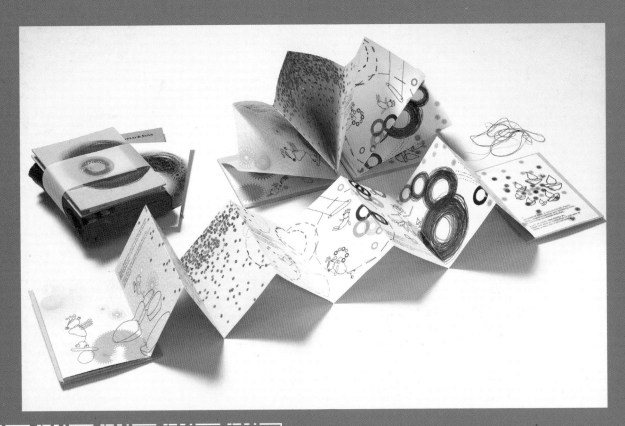

USINE DE BOUTONS Unusual illustrations and
CARILLON, IDENTITY PACKAGE striking calligraphy play an
important role within the
hierarchy of Carrillon, designed for Replay & Sons. However,
it is the bold use of the large, bright orange, circular image
that really captures the viewer's attention. This distinctive hue
is replicated within other items in the identity—including
textile products, postcards, and label ties—and acts as a
focus that pulls viewers from orange to orange, and to the
less impactive surrounding information.

CLIENT
MEM MORRISON

DESIGN
DOM RABAN

ART DIRECTION
DOM RABAN

EG.G
SHOWROOM THEATER POSTER

This Showroom poster was an interesting challenge, particularly from a hierarchical point of view: it has to work as a cohesive whole and as six individual flyers. The whole poster therefore includes the same information six times. This is skillfully varied in scale and interpretation so as not to appear repetitive or symmetrical. Each individual flyer has a strong focal emphasis and sufficient supporting visual material to give it credibility. The 18-column grid of the whole (breaking down into six three-column flyers) acts both as a unifying and dividing device. By combining type in bars with iconic images, the demarcation between type and image is blurred, allowing intensity of color and tone alone to draw in the eye of the viewer.

CLIENT	DESIGN	TYPOGRAPHY
MTV NORTHERN EUROPE	ROB COKE	ROB COKE

COPYWRITING	ART DIRECTION	ILLUSTRATION
OTTO RIEWOLDT	ROB COKE	ROB COKE

STUDIO OUTPUT LTD.
MTV SOUND SYSTEM

Although a great deal of type is included in all these posters, we have included them in the image-driven section of this book for two reasons; firstly, the images are either of animated, cut-out figures or of powerful red, orange, and green rastafarian circles both of which immediately draw attention; secondly, the type, which includes a number of namestyles, uses the same color combinations as the images, reversed through allover black or blue backgrounds. Therefore, type merges into image so that each poster is perceived instantly on an image basis before it is "unpacked" for information. As far as the hierarchy of this data is concerned, it is likely that tonal values of each element take a reader from light to dark; familiar aspects draw more attention, and individuals' personal "need to know" requirements will influence their point of entrance.

THANKS2

344 DESIGN, LLC
101 N. Grand Avenue #7 Pasadena, California 91103, USA
T: +1 626 796 5148

BLUE RIVER DESIGN LTD.
Kings House, Fourth Banks, Newcastle, Tyne and Wear
NE1 3PA, UK
T: +44 (0)191 261 0000 F: +44 (0)191 261 0010

BRAHM DESIGN
Brahm Building, Alma Road, Headingley, Leeds, West
Yorkshire LS6 2AH, UK
T: +44 (0)113 230 4000 F: +44 (0)113 230 2332

BRIGHT PINK COMMUNICATIONS DESIGN
Lapley Studio, Lapley, Stafford ST19 9JS, UK
T: +44 (0)1785 841601 F: +44 (0)1785 841401

BUREAU FOR VISUAL AFFAIRS
24 Southwark Street, London SE1 1TY, UK
T: +44 (0)207 407 2582

CHENG DESIGN
505 14th Avenue E #301, Seattle, Washington 98112, USA
T: +1 206 328 4047 F: +1 206 685 1657

DOYLE PARTNERS
1123 Broadway, New York, New York 10010, USA
T: +1 212 463 8787 F: +1 212 633 2916

DWELL
99 Osgood Place, San Francisco, California 94133, USA
T: +1 415 743 9990 F: +1 415 743 9978

EG.G
Swan Buildings, 20 Swan Street, Manchester M4 5DW, UK
T: +44 (0)161 833 4747 F: +44 (0)161 833 4848

FISHTEN
2203 32nd Avenue, SW Calgary, Alberta T2T 1X2, Canada
T: +1 403 228 7959

FORM FUENF BREMEN
Graf Moltke Strasse 7, 28203, Bremen, Germany
T: +49 421 703074 F: +49 421 703740

GEE + CHUNG DESIGN
38 Bryant Street, Suite 100, San Francisco,
California 94105, USA
T: +1 415 543 1192 F: +1 415 543 6088

**GR/DD GRAPHIC RESEARCH DESIGN
DEVELOPMENT**
173 Clapham Road, Stockwell, London SW9 0QE, UK
T: +44 (0)207 733 2287 F: +44 (0)207 733 2257

GRANT MEAK
15B Westbourne Street, Walsall, West Midlands
WS4 2JB, UK
T: +44 (0)1922 624643

HOLLER
151 Farringdon Road, London EC1R 3AF, UK
T: +44 (0)207 689 1940

IDENTIKAL
9A Wood Lofts, 30–40 Underwood Street, London
N1 7JQ, UK
T: +44 (0)207 253 6771 F: +44 (0)795 749 7569

IE DESIGN + COMMUNICATIONS
422 Pacific Coast Highway, Hermosa Beach,
California 90254, USA
T: +1 310 376 9600 F: +1 310 376 9604

JOHNSON BANKS
Crescent Works, Crescent Lane, Clapham, London
SW4 9RW, UK
T: +44 (0)207 587 6400 F: +44 (0)207 587 6411

KINETIC, SINGAPORE
2 Leng Kee Road, Thye Hong Ctr #004–03 159086
Singapore
T: +65 637 95320 F: +65 647 25440

MATEEN KHAN
4 Kirby Road, Leicester LE3 6BA, UK
T: +44 (0)116 299758

MIRKO ILIC CORP.
East 32nd Street, New York, New York 10016, USA
T: +1 212 481 9737 F: +1 212 481 7088

MUGGIE RAMADANI
Rosenvængets Allé 17B, 3rd Floor, Copenhagen – Østerbro
DK2100, Denmark
T: +45 40748930

NB: STUDIO
24 Store Street, London WC1E 7BA, UK
T: +44 (0)207 580 9195 F: +44 (0)207 580 9196

NON-FORMAT
2nd Floor East 88–94 Wentworth Street, London
E1 7SA, UK
T: +44 (0)207 422 5035

ODED EZER DESIGN STUDIO
9 Bloch Street, Givatayim 53229, Israel
T: +972 3 672 5489 F: +972 3 672 5489

PHILIP FASS
University of Northern Iowa, 104 Kamerick Art Building,
Cedar Falls, Iowa 50614, USA
T: +1 319 277 6120 F: +1 319 273 7333

PISCATELLO DESIGN CENTRE
355 Seventh Avenue, New York, New York 10001, USA
T: +1 212 502 4734 F: +1 212 502 4735

POULIN + MORRIS INC.
286 Spring Street, 6th Floor, New York,
New York 10013, USA
T: +1 212 675 1332 F: +1 212 675 3027

RADFORD WALLIS
3rd Floor, 27 Charlotte Road, London EC2A 3PB, UK
T: +44 (0)207 033 9595 F: +44 (0)207 033 9585

REBECCA FOSTER DESIGN
54 Cassiobury Road, London E17 7JF, UK
T: +44 (0)208 521 8535 F: +44 (0)208 521 5784

RECHORD
Innovation Labs, Harrow Campus, Watford Road,
Harrow HA1 3TP, UK
T: +44 (0)20 8357 7322 F: +44 (0)20 8357 7326

SAGMEISTER INC.
222 West 14 Street, New York, New York 10011, USA
T: +1 212 6471789 F: +1 212 6471788

SAS
6 Salem Road, London W2 4BU, UK
T: +44 (0)207 243 3232 F: +44 (0)207 243 3216

SCANDINAVIAN DESIGN GROUP
P.O. Box 4340 Nydalen, Oslo, N-0402 Norway
T: +47 2254 9500

SPARKS PARTNERSHIP
85A Goldsmiths Row, Bethnal Green, London E2 8QR, UK
T: +44 (0)20 7240 7181

SPIN
12 Canterbury Court, Kennington Park, London SW9 6DE, UK
T: +44 (0)207 793 9555 F: +44 (0)207 793 9666

STUDIO OUTPUT LTD.
2 The Broadway, Lace Market, Nottingham NG1 1PS, UK
T: +44 (0)115 950 7116 F: +44 (0)115 950 7924

STUDIO VERTEX
108 S. Washington Street #310, Seattle, Washington
98104, USA
T: +1 206 838 2450

SURFACE MAGAZINE
1663 Mission Street, Suite 700, San Francisco,
California 94103, USA
T: +1 415 575 3100 F: +1 415 575 3105

TAXI STUDIO LTD.
93 Princess Victoria Street, Clifton, Bristol BS8 4DD, UK
T: +44 (0)117 973 5151 F: +44 (0)117 973 5181

TEIKNA GRAPHIC DESIGN INC.
401 Logan Avenue #208, Toronto, Ontario
M4M 2P2, Canada
T: +1 416 504 8668 F: +1 416 465 9998

USINE DE BOUTONS
Via G. Franco 99B, Cadoneghe, Padua 35010, Italy
T: +39 (0)49 8870953 F: +39 (0)49 8879520

WAITROSE LTD.
Don Castle Road, Bracknell, Berkshire RG12 8YA, UK

WILSON HARVEY
Crown Reach, 147a Grosvenor Road, London SW1V 3JY, UK
T: +44 (0)207 420 7700

Z3 DESIGN STUDIO INC.
Loft 2 Broughton Works, 27 George Street,
Birmingham B3 1QG, UK
T: +44 (0)121 233 2545 F: +44 (0)121 233 2544

INDEX